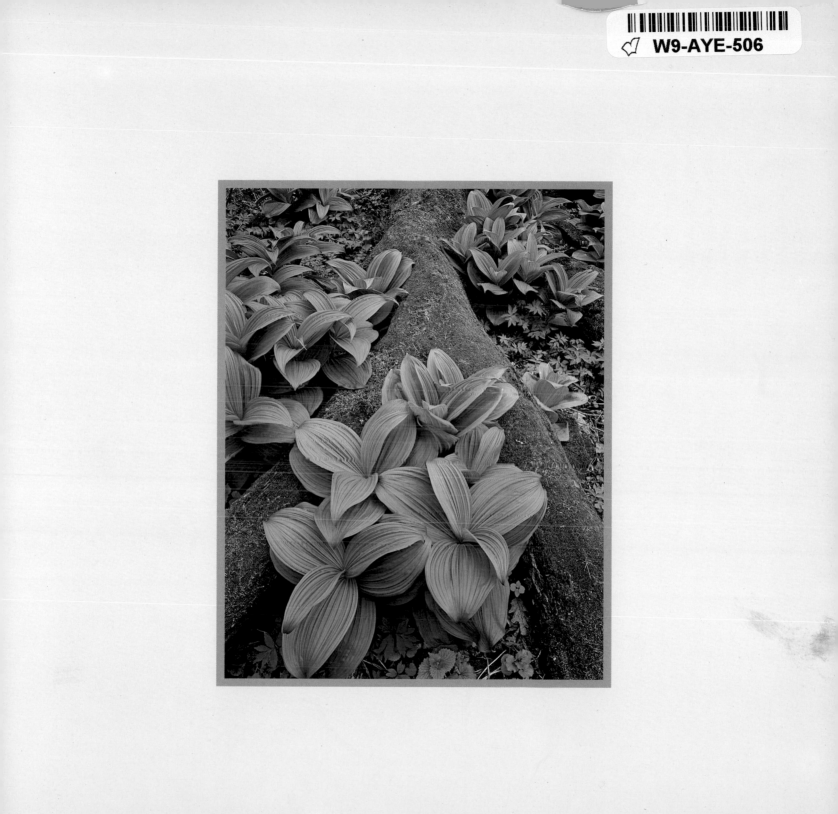

shenandoah
WONDER AND LIGHT

Photography by Ian J. Plant

Mountain Trail Press

1818 Presswood Road • Johnson City, Tennessee 37604
www.mountaintrailpress.com

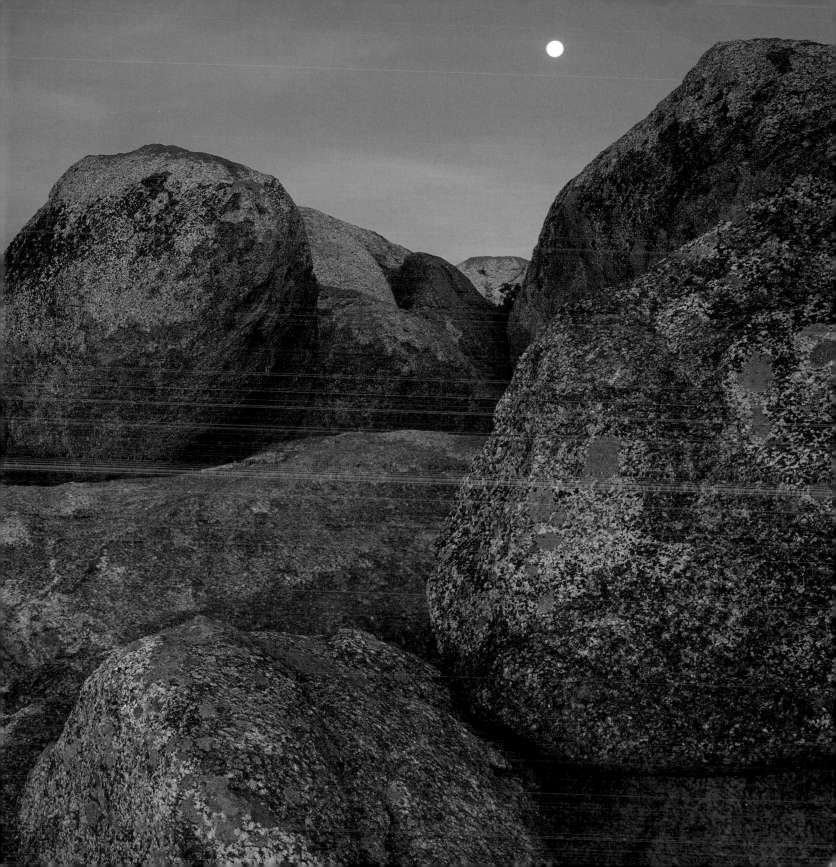

shenandoah
WONDER AND LIGHT

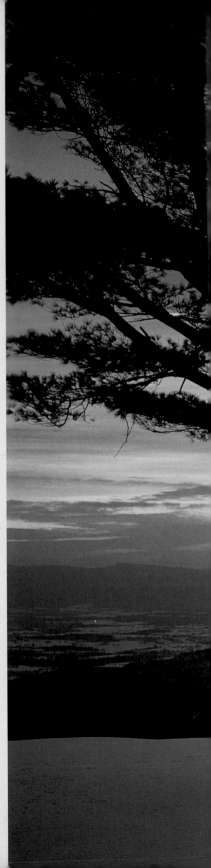

Photography by Ian J. Plant

Book design and layout by Jerry Greer and Ian Plant.
Editing by Todd Caudle.
Entire Contents Copyright © Mountain Trail Press LLC 2005.
Photographs Copyright © Ian J. Plant 2005.
All Rights Reserved.
No part of this book may be reproduced in any form without written
permission from the publisher, except by a reviewer who may quote
brief passages or reprint a photograph.

Published by Mountain Trail Press LLC
1818 Presswood Road
Johnson City, TN 37604

ISBN: 0-9676938-7-X
Printed in Korea
First printing, Spring 2005

Front cover: Big Falls of Overall Run

First frontpiece: Clumps of false hellebore grow around a fallen tree

Previous page: Alpenglow and moonrise paint surreal colors on the
summit boulders of Old Rag Mountain

Right: Winter sunset over Pass Mountain

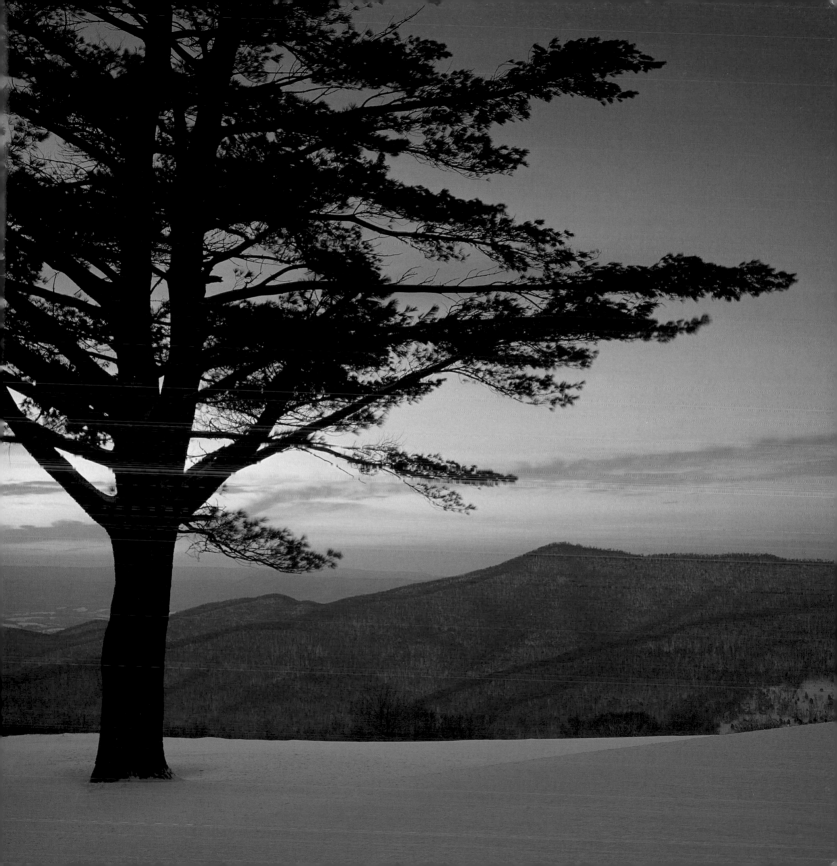

Introduction

"Shenandoah" is a Native American name that has had many meanings assigned to it. Some have argued that the name flows from a Native word meaning "the river through the spruce." Others have argued that the name is derived from another word meaning "the river flowing near high mountains." Still others believe that the name derives from the fallen Iroquois chief Sherando, who lived near the headwaters of what is now called the Shenandoah River. All of these meanings, however, are associated with the Shenandoah River and the famous Shenandoah Valley. None have a particularly strong connection with the mountains that form the backbone of Shenandoah National Park.

The most romantic meaning associated with the word Shenandoah, and by far the most popular, is "daughter of the stars." It is a meaning, I think, that also best describes the mountains that make Shenandoah National Park. Formed over a billion years ago when magma deep beneath the earth's surface moved upward, the Park's granite peaks have been softened by eons of erosion to the more gentle rolling ridges seen today. Some places, however, retain the vestiges of the mountains' ancient and violent origins. Most notable to me is the craggy summit of Old Rag Mountain, resplendent with precipitous cliffs and massive boulders. When I think of Shenandoah National Park, I think of Old Rag bathed in the eerie glow of twilight, when the twisted summit boulders take on a preternatural appearance, and a thousand distant

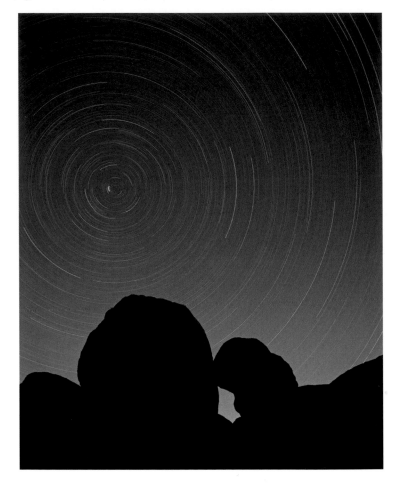

worlds begin their slow journey across the sky. To me, as I lie beneath my camera while the stars trace on film their arcing passage through the heavens, Daughter of the Stars is a meaning that is uniquely fitting to this jewel of the National Park system.

Shenandoah National Park, however, is more than just granite. The Park is home to dozens of cascading streams and plunging waterfalls, abundant wildlife, and uncounted trees. But it has not always been so. For at least 10,000 years humans have lived, hunted, and settled in the area, leaving their imprint on the wilderness. By the time that Shenandoah National Park was established, some of the Park's forests had been logged or burned, and the Park's populations of deer, bear, and turkey were near extirpation. Now almost seven decades under the aegis of the National Park Service, Shenandoah has had a remarkable recovery, and stands as a testament to the power of nature, if left alone, to reclaim its wildness.

Human beings, too, have the capacity to reclaim something of their wild nature, when confronted by the majesty and beauty of an unmarred natural world. It is likely that this search for wildness within our selves has motivated the preservation of the wilderness without. Certainly, such was the motivation of the visionaries who conceived and brought to fruition Shenandoah National Park. A number of Virginians, including George Freeman Pollock, manager of the popular Skyland resort, promoted a national park site in the northern Virginia Blue

Ridge Mountains (it is probably of little coincidence that Pollock's resort was located at what is now the very heart of Shenandoah National Park). In 1926 the U.S. Congress accepted their proposal, passing a law authorizing the Park, but only on the condition that no federal funds would be spent in acquiring land. Over the next ten years, the Commonwealth of Virginia, using state money and funds donated by some private citizens, acquired land for the park and donated it to the federal government. Finally, in 1936, Shenandoah National Park was dedicated by President Franklin D. Roosevelt.

The famous Skyline Drive, which runs 105 miles along the Blue Ridge from the northern border of the Park near Front Royal to the southern border where it connects with the Blue Ridge Parkway, was built between 1931 and 1939 by a combination of local farmers, government contractors, and eventually, the Civilian Conservation Corps. President Herbert Hoover, who had a fishing camp in the park area, is often credited with the idea of Skyline Drive. He is reported to have said "these mountains are made for a road." Although I cannot exactly warm to the sentiment that any mountains are made for a road, Skyline Drive does provide many park visitors with a unique opportunity for access to many high mountain vistas and spectacular wilderness areas.

Despite its many wonderful views, one has to leave Skyline Drive to truly experience the magnificence of Shenandoah National Park and to discover its hidden rhythms. Certainly some of the most popular trails, such as Whiteoak Canyon and Old Rag, are areas of superlative beauty. To me, some less visited areas, such as Whiteoak's often overlooked neighbor Cedar Run, offer the same beauty, albeit on a more intimate scale. Shenandoah is replete with such intimate landscapes. Indeed, it is the intimate landscape that draws my attention and fires my imagination most, and provides the strongest connection to the natural world.

I invite you to view Shenandoah National Park through my eyes. It is a view, to be sure, which may differ at times from the glimpse of the Park offered to the casual tourist driving on Skyline Drive. I invite you, then, to discover with me Shenandoah's hidden treasures, those found off the beaten path. I can only hope that my images convey to you even a fraction of the power and beauty that inspires my work.

Ian J. Plant
June 1, 2004

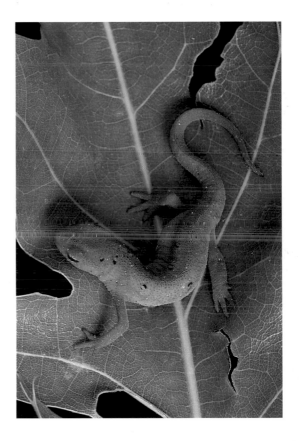

Left: Star trails trace the passage of distant galaxies across the night sky, as seen from the summit of Old Rag Mountain

Above: A red eft pauses on a leaf

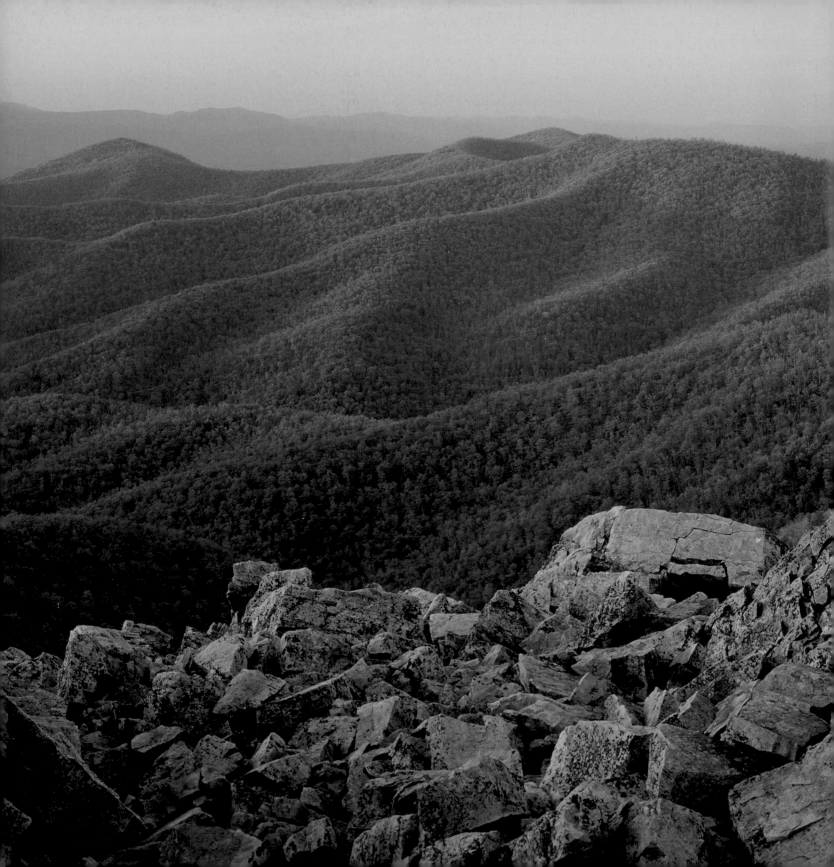

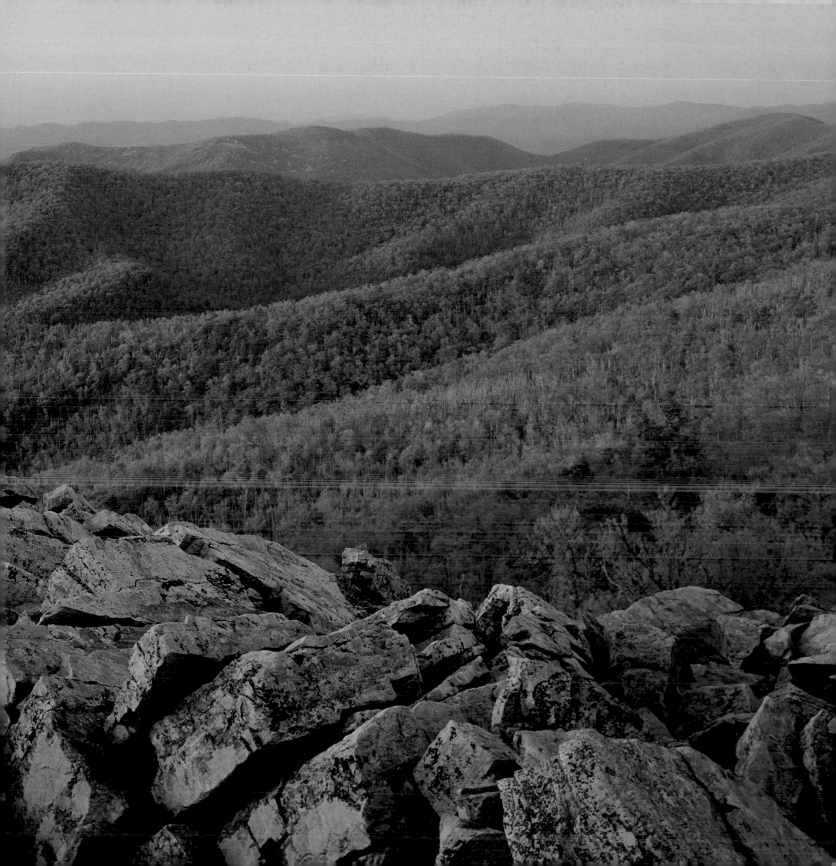

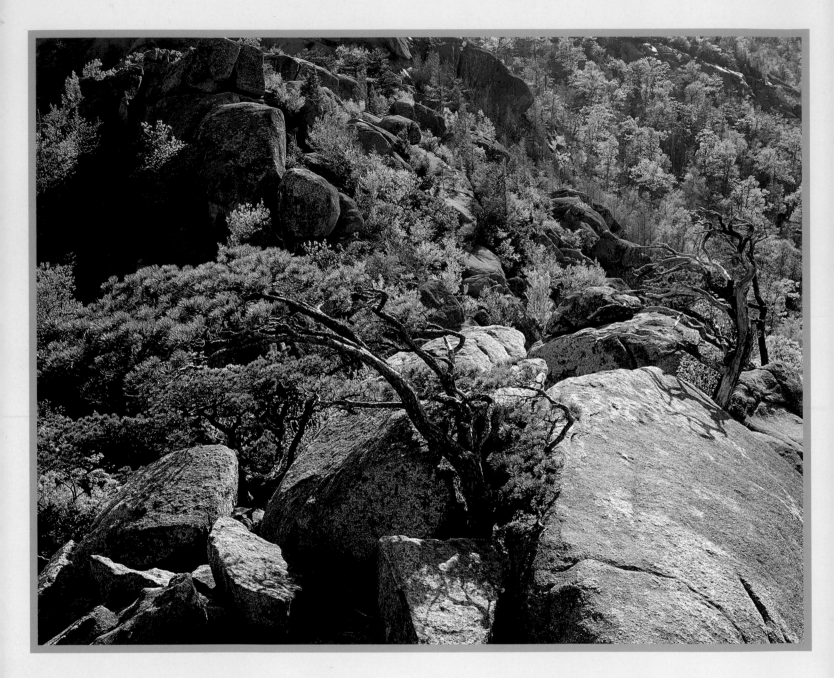

Previous page: Sunset over the Blue Ridge Mountains, as seen from the jumbled toprock of Blackrock Mountain

Above: Along the Ridge Trail ascending Old Rag Mountain

Right: A natural staircase along the Ridge Trail

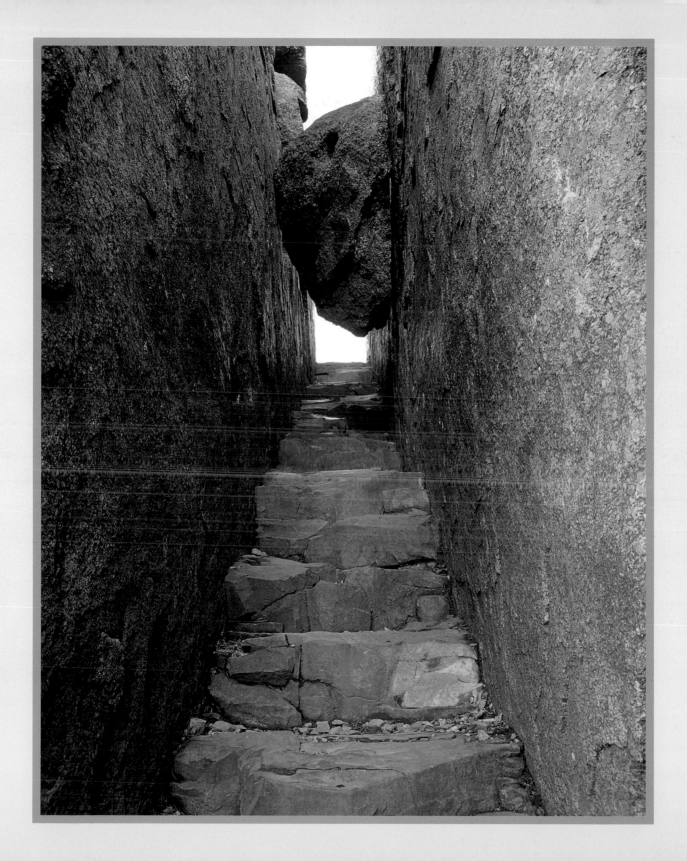

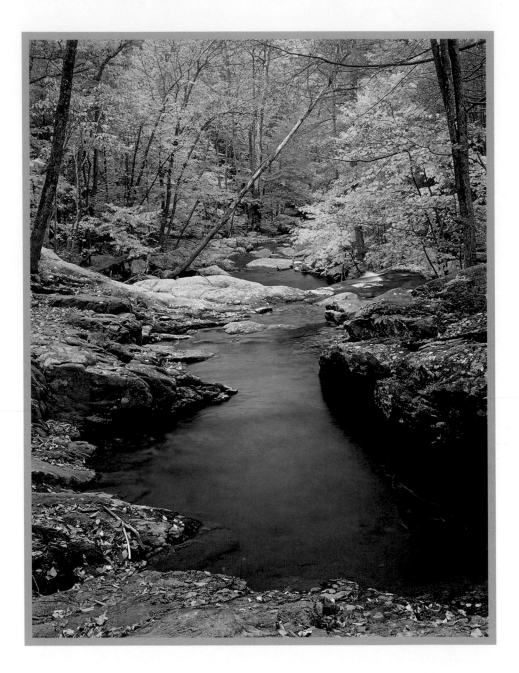

Autumn view of Whiteoak Canyon

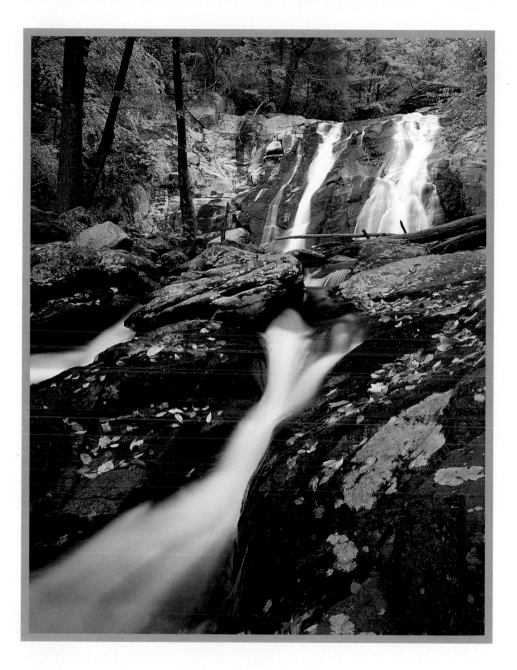

Lower Whiteoak Canyon Falls

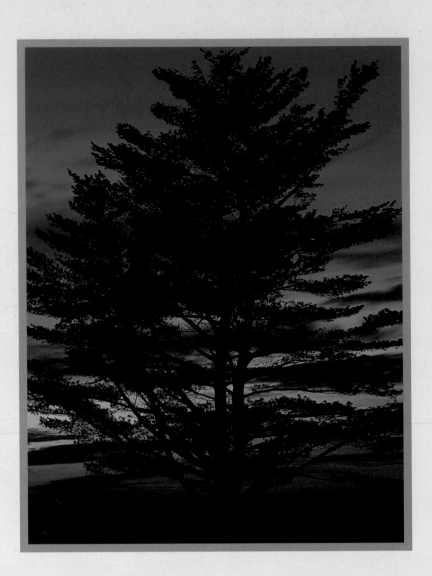

Above: Sunset paints rainbow hues on the night sky

Right: Dawn twilight over the Blue Ridge Mountains

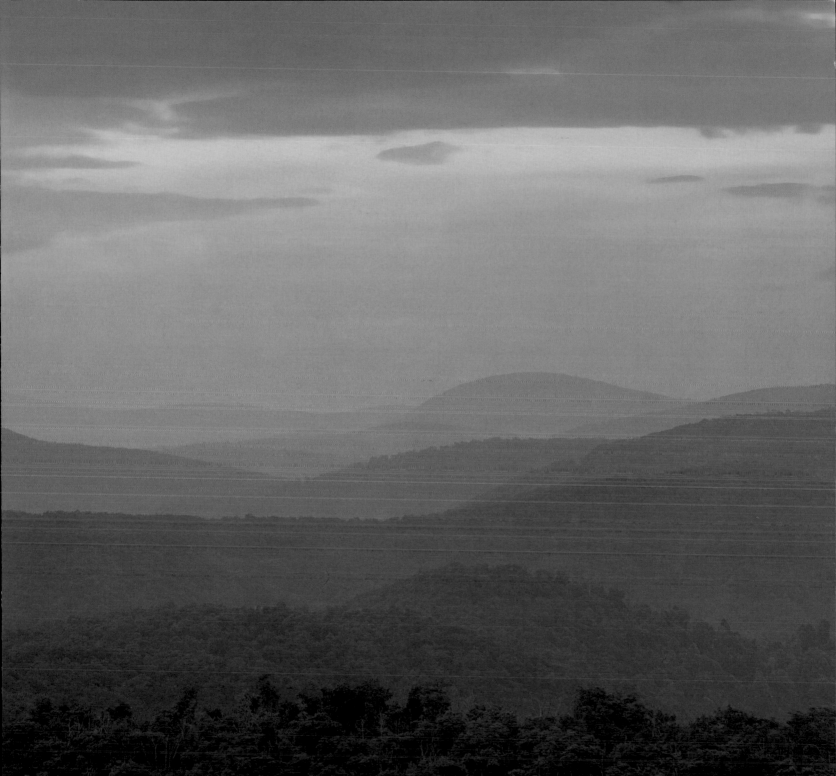

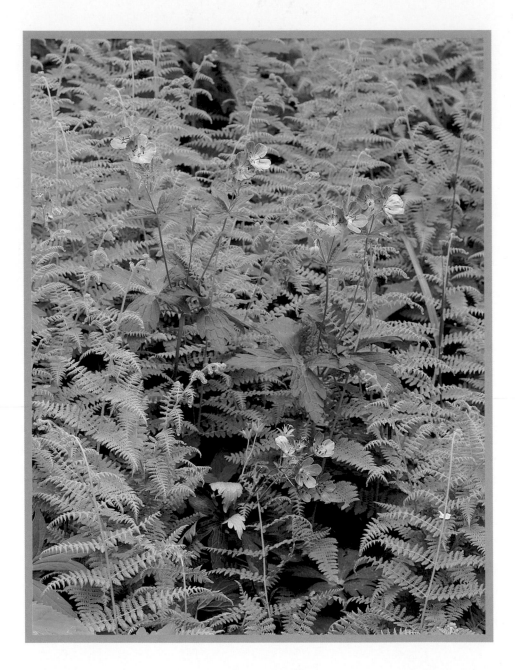

Cranesbill and ferns

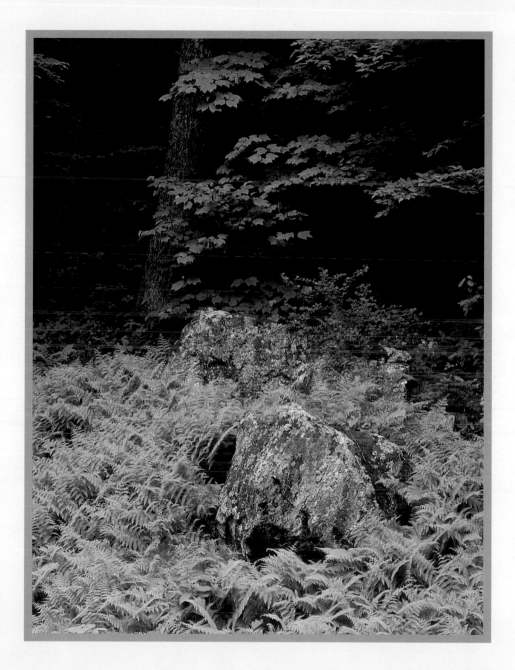

Ferns grow in profusion along Skyline Drive during the summer months

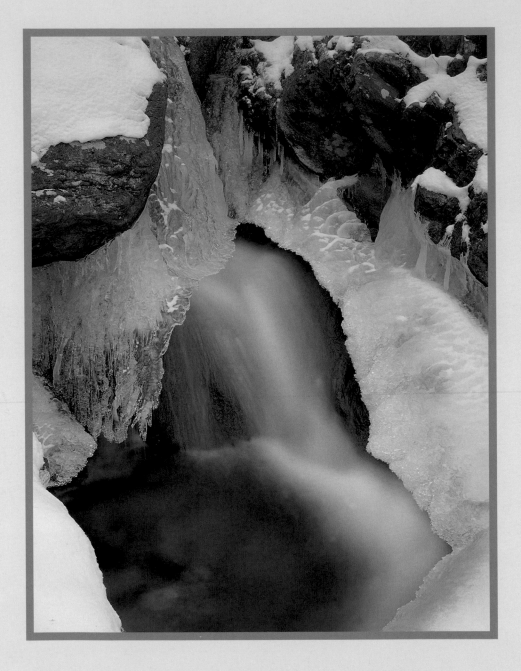

Winter's chill creates sculpted ice along Cedar Run

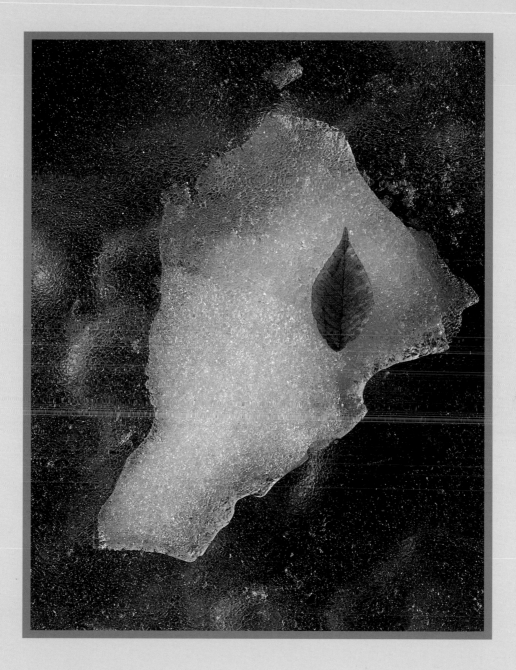

The rich blues and whites of ice contrast with autumn's gold, frozen in time

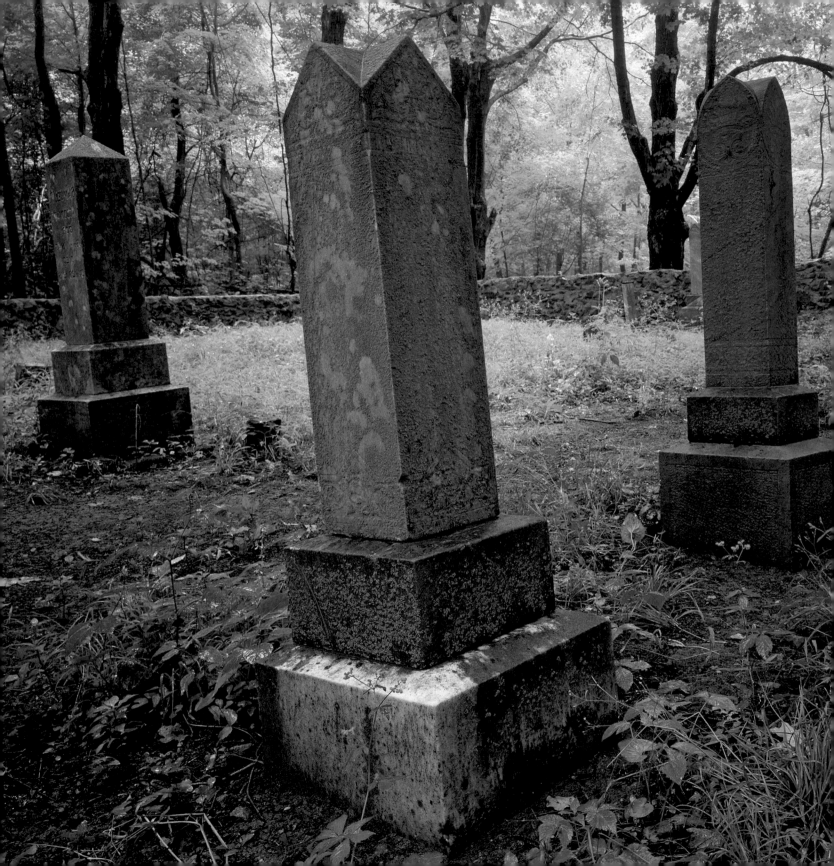

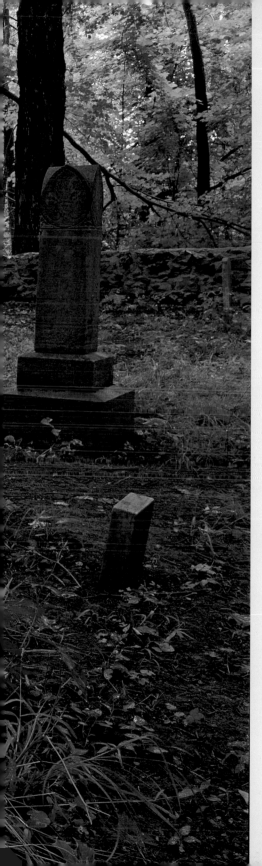

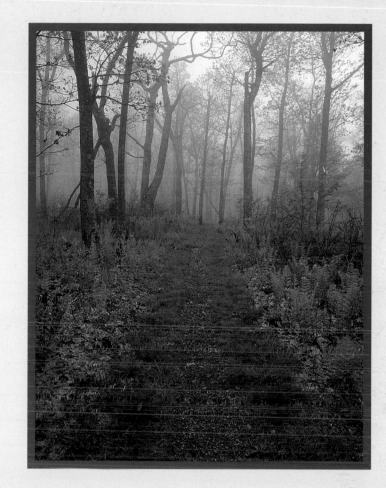

Left: Crooked tombstones heave from the earth in Bolen Cemetery

Above: Mist shrouds the Appalachian Trail as it passes through Shenandoah National Park

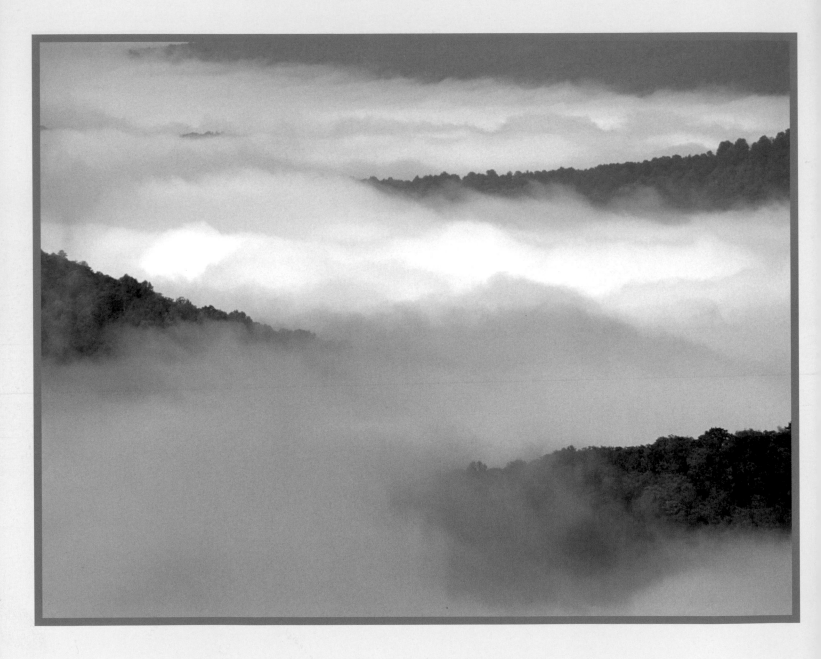

A view above the clouds, from Skyline Drive

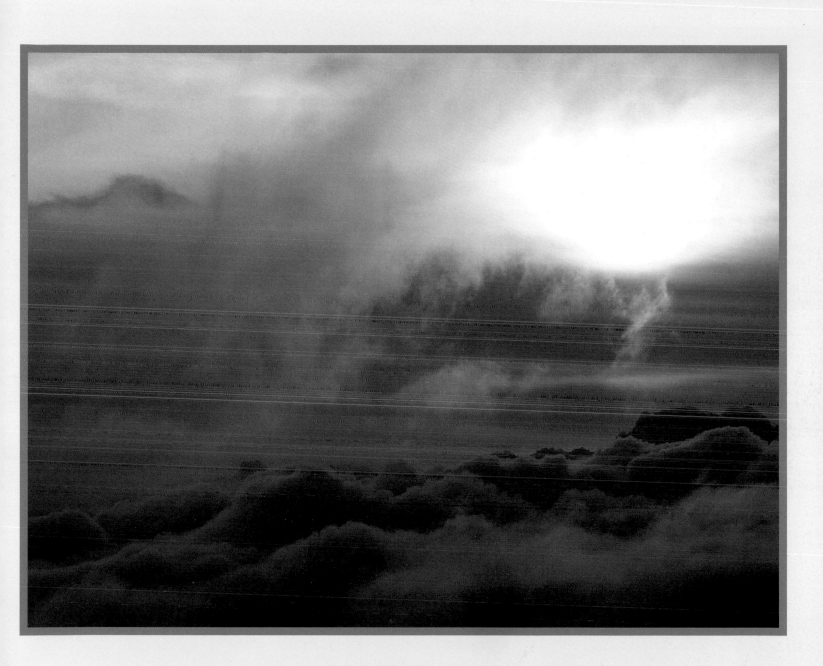

The sun bursts through a passing storm

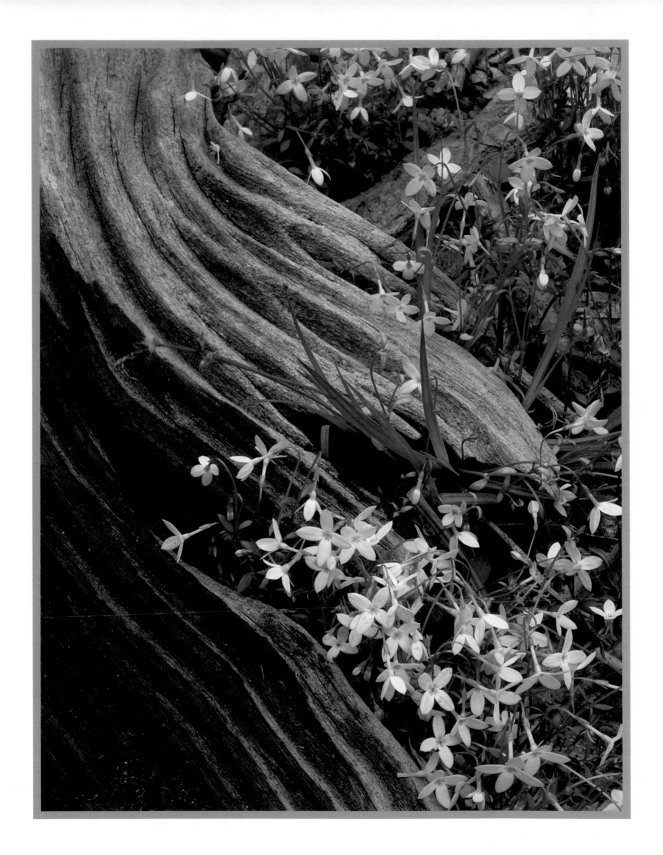

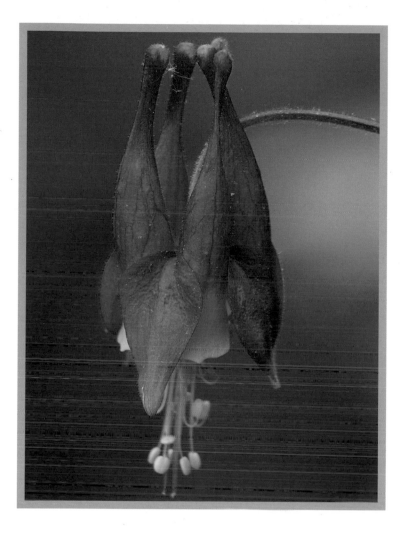

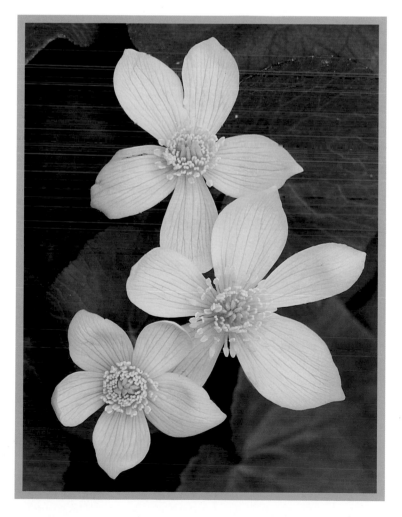

Left: Bluets spring forth through wildfire-burnt wood

Above: Columbine blooms in profusion during summer

Right: Marsh marigold

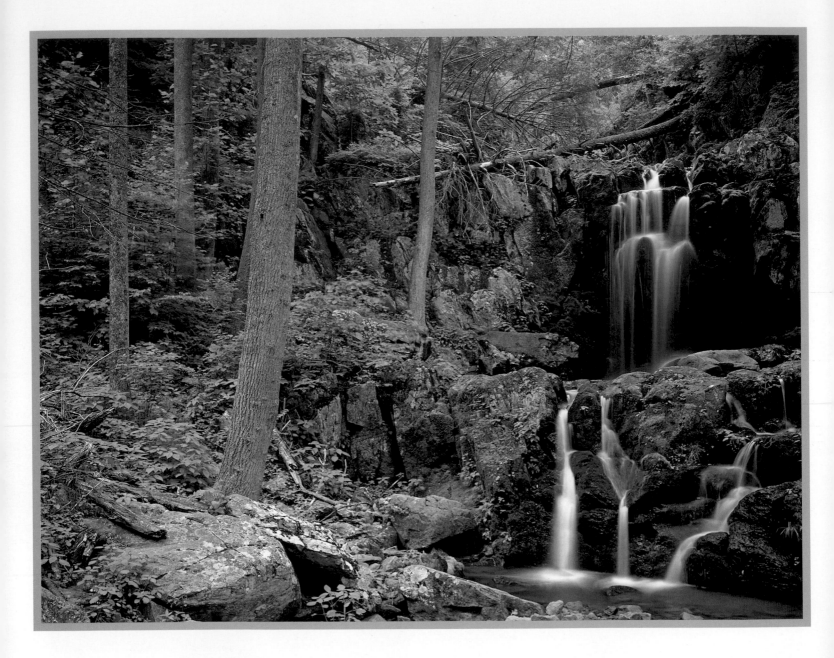

Above: Upper Doyles Falls

Right: Upper Jones Run Falls

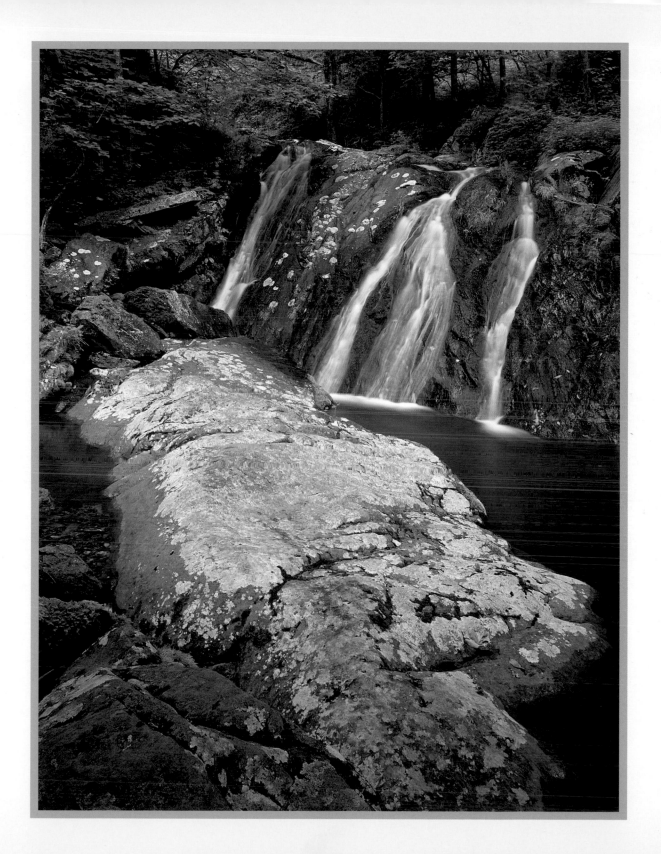

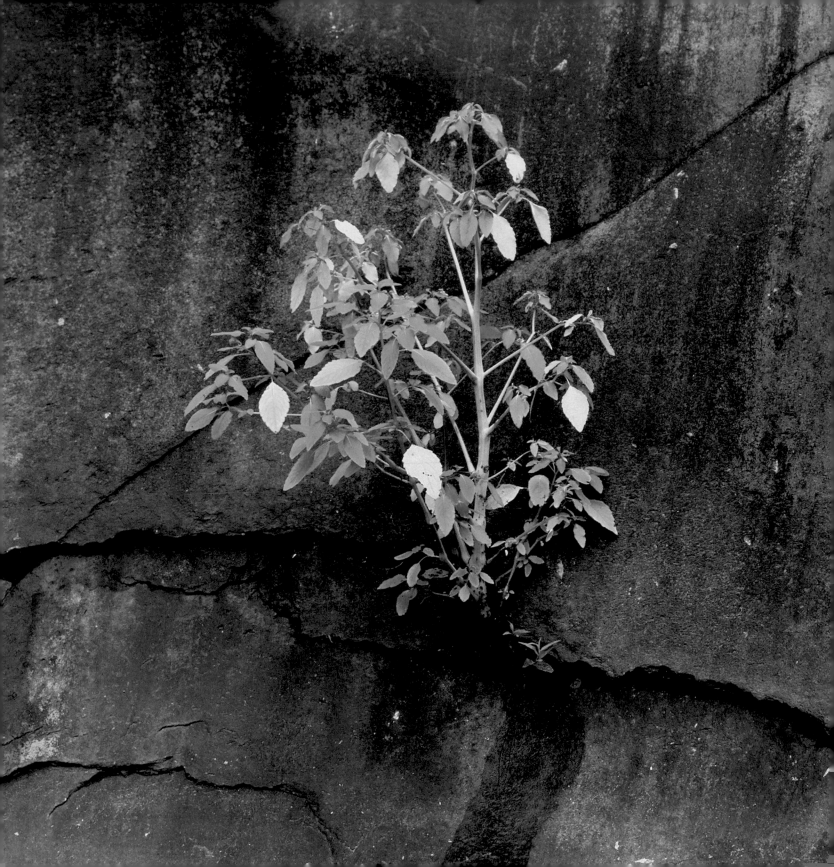

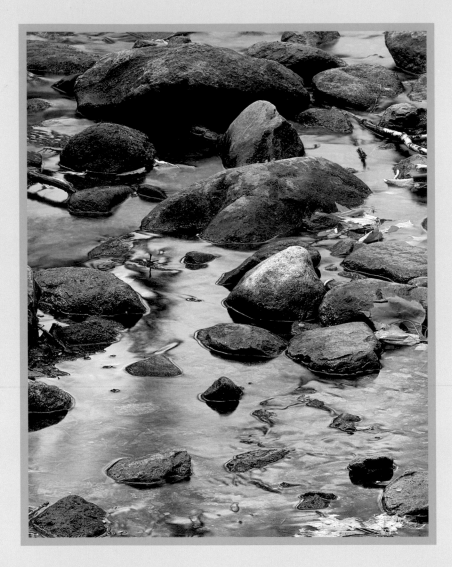

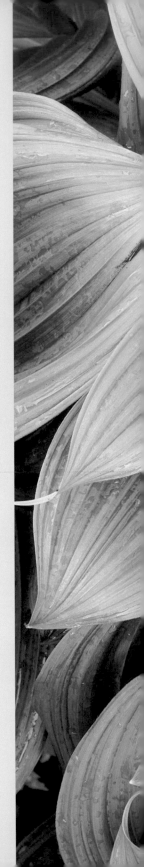

Previous page: A tree grows out of a cliff

Above: Spring's greens reflected in a pool of water

Right: Raindrops on false hellebore leaves

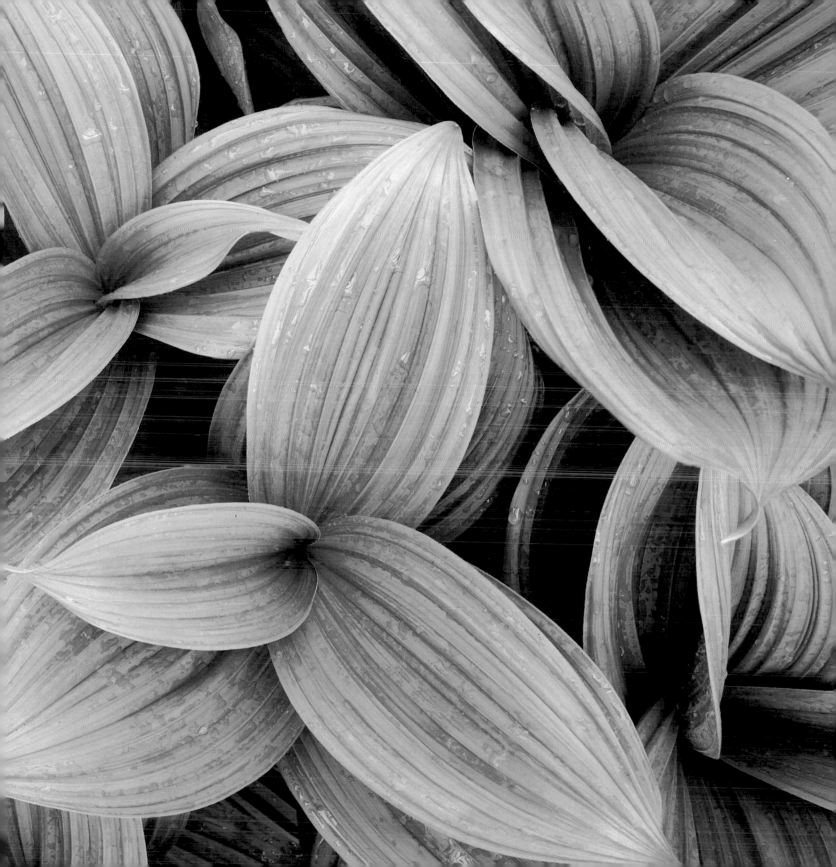

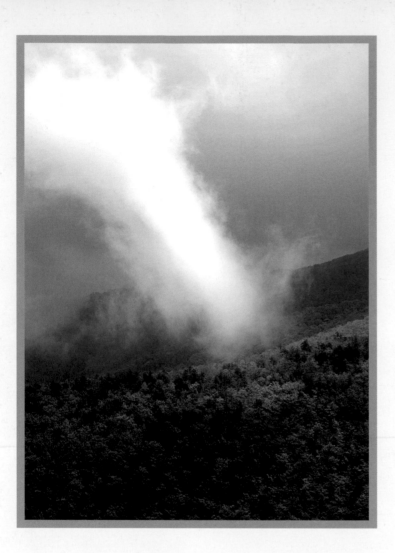

Above: A pillar of fog rises above the mountains

Right: The sun breaks through fog

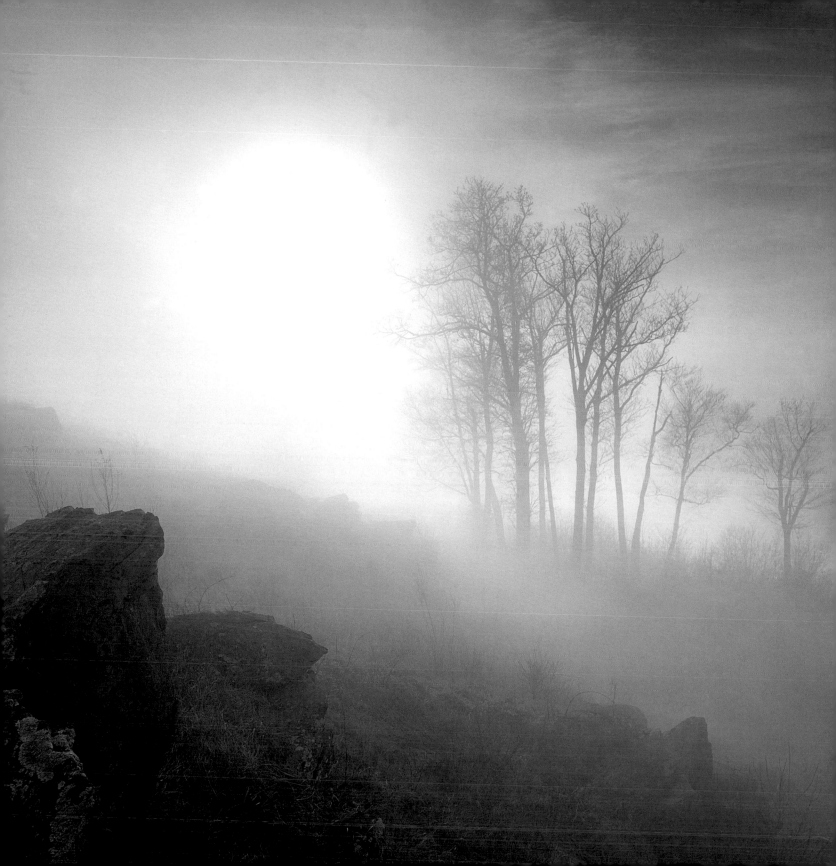

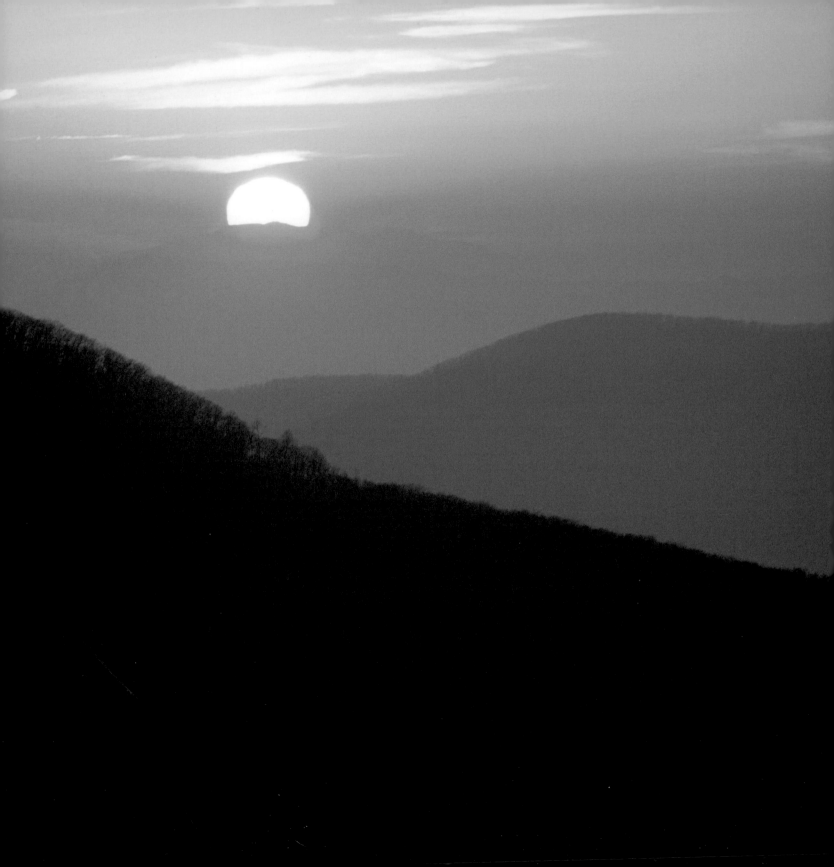

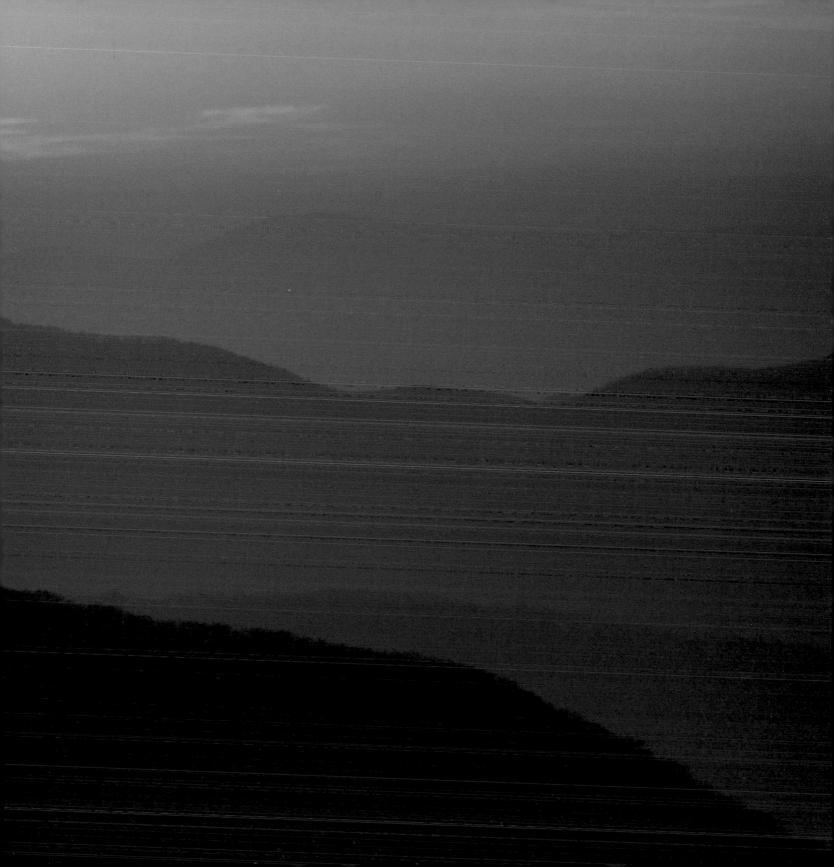

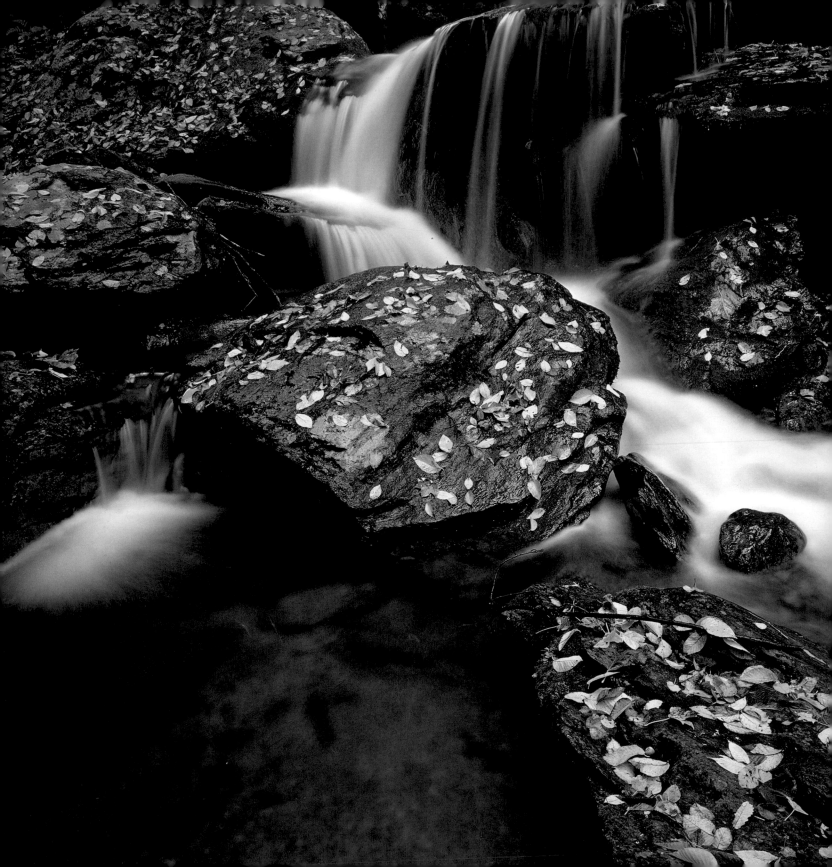

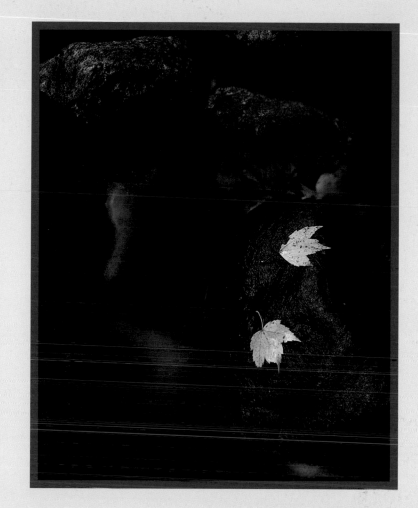

Previous page: A magical sunset descends over Tanners Ridge

Left: Autumn's touch graces Middle Cedar Run Falls

Above: Two fallen leaves lie perched atop a boulder

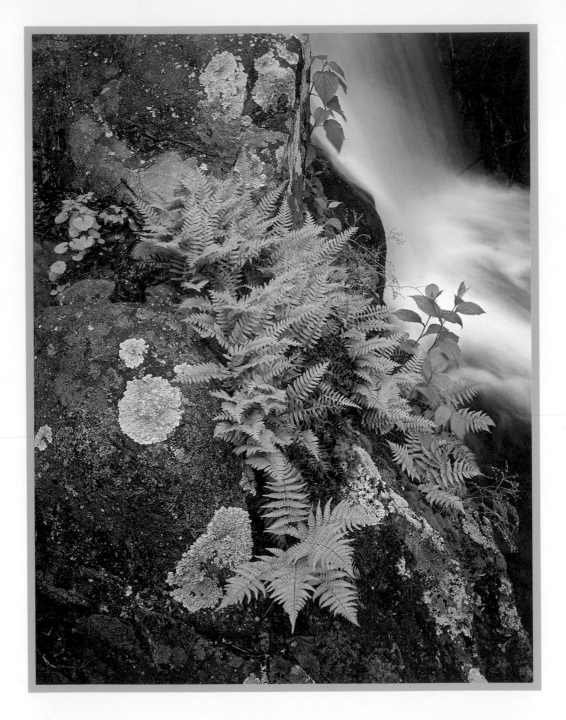

Ferns along Doyles River

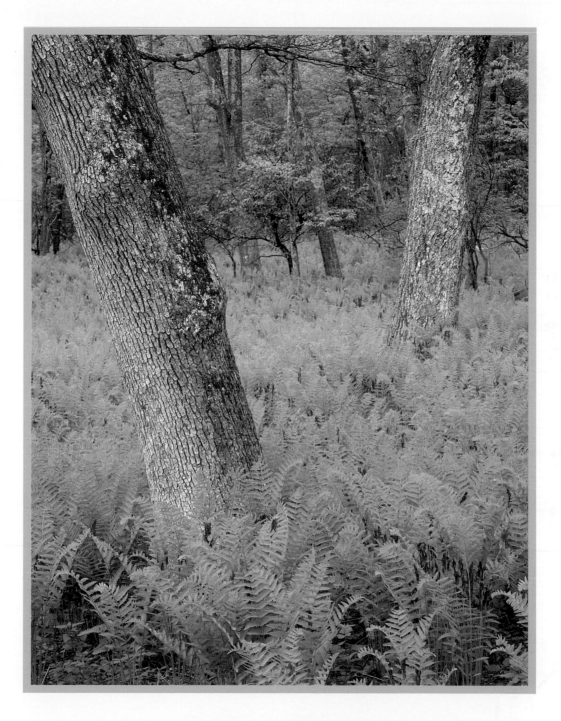

A sea of ferns engulfs slanted trees

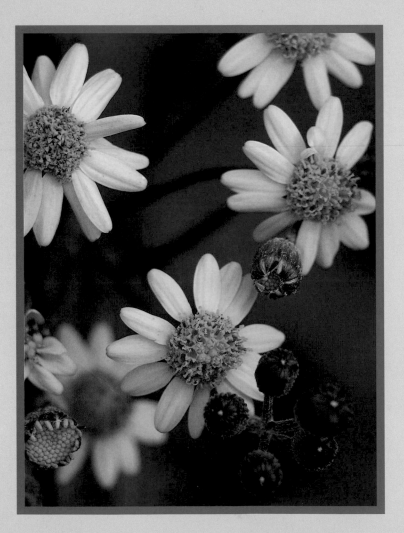

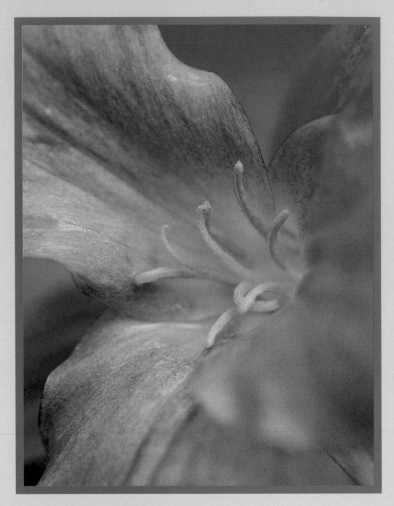

Left: Golden ragwort

Above: Trillium

Right: Violets bloom through pine cones

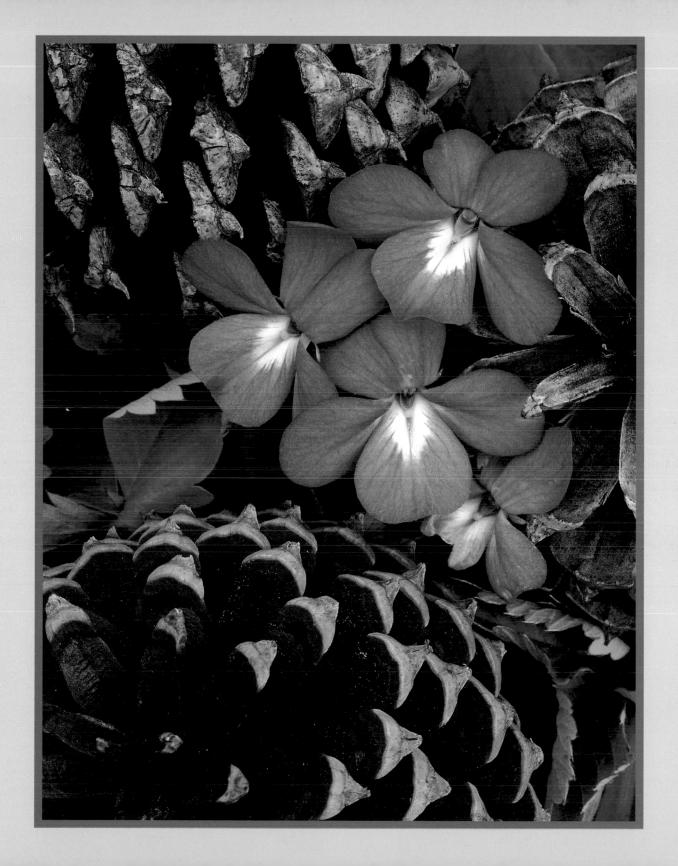

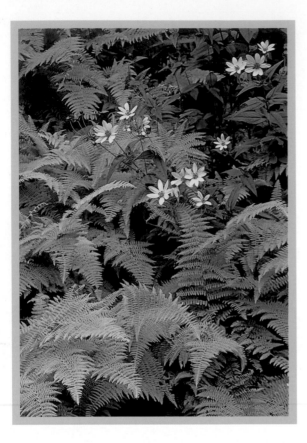

Above: Woodland sunflowers and ferns

Right: Spring view of Dark Hollow Falls

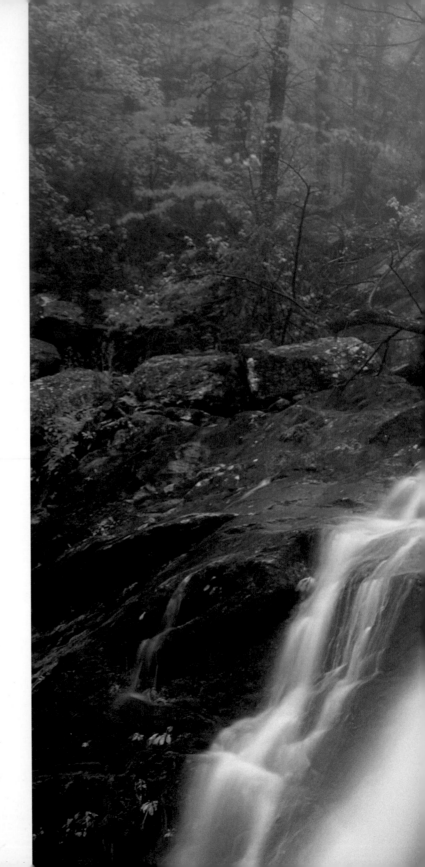

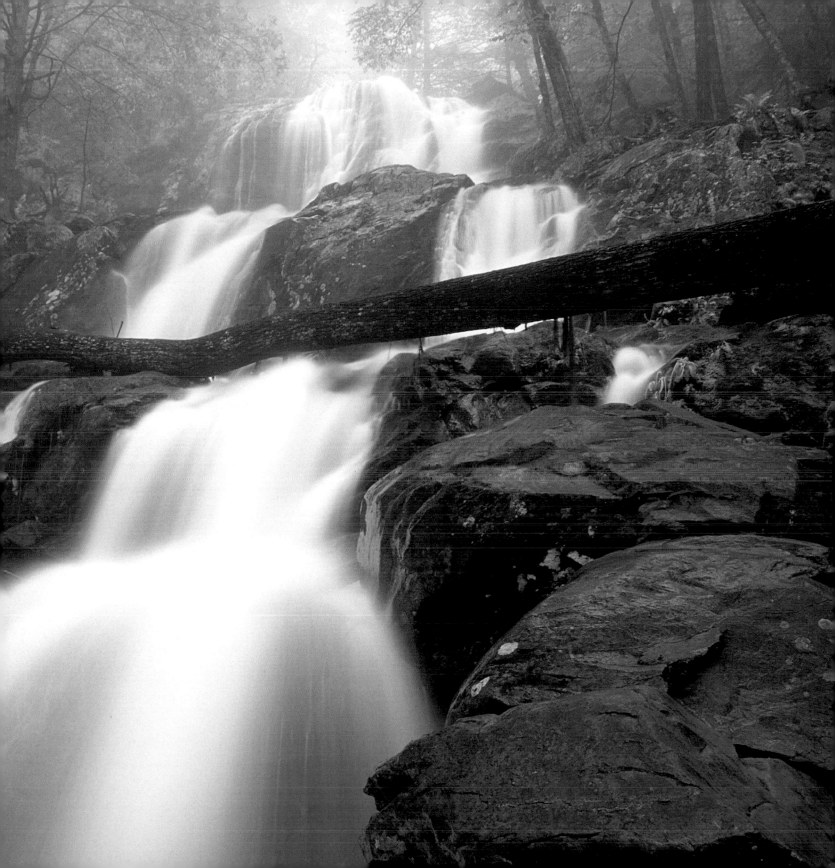

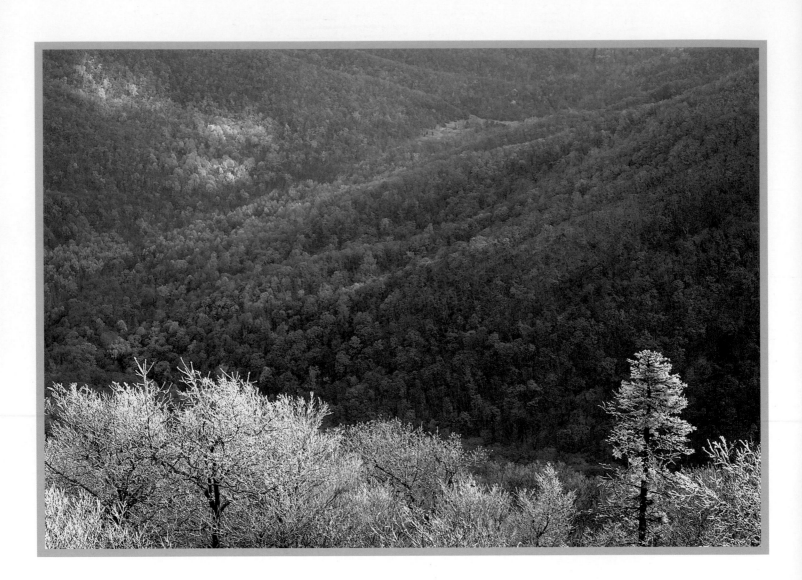

Previous page: Lichen-covered cliffs serve as camoflauge for grey-barked trees

Above: Autumn frost

Right: Winter view of Dark Hollow Falls

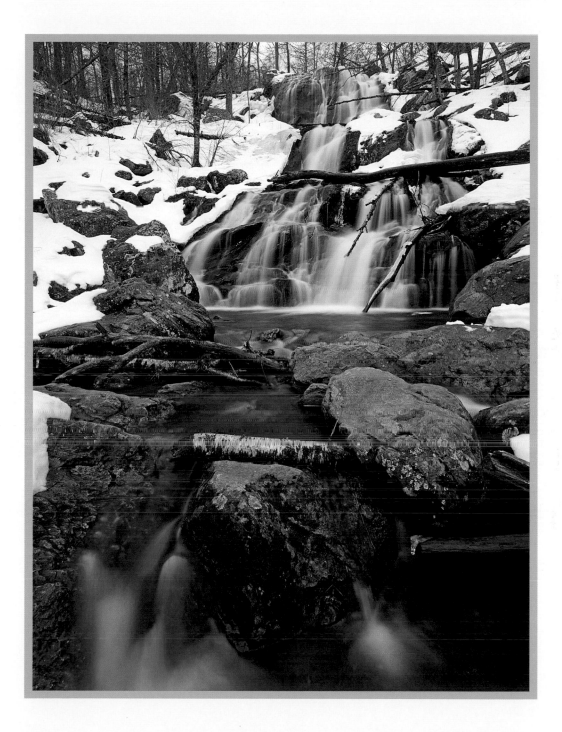

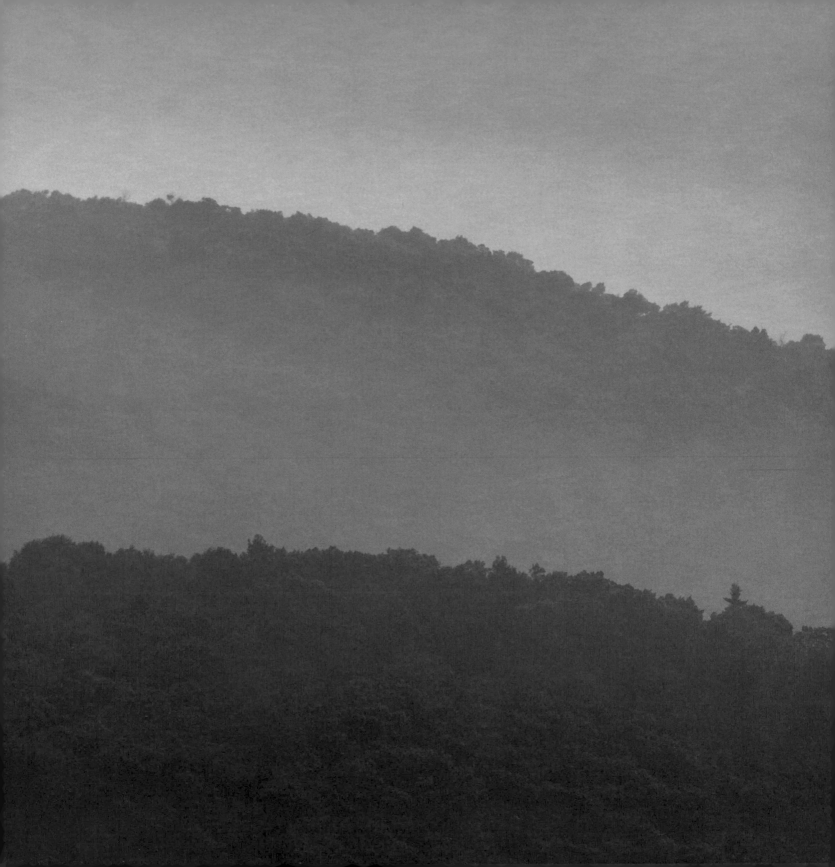

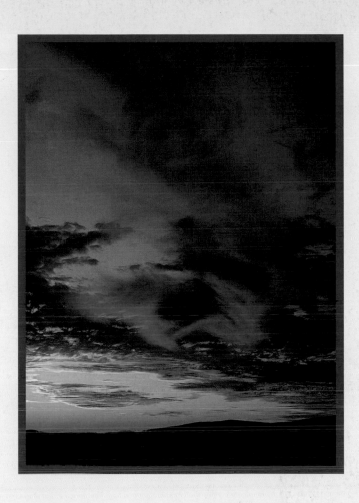

Left: Blue haze settles over the Blue Ridge Mountains

Above: High altitude clouds catch the last rays of sunlight

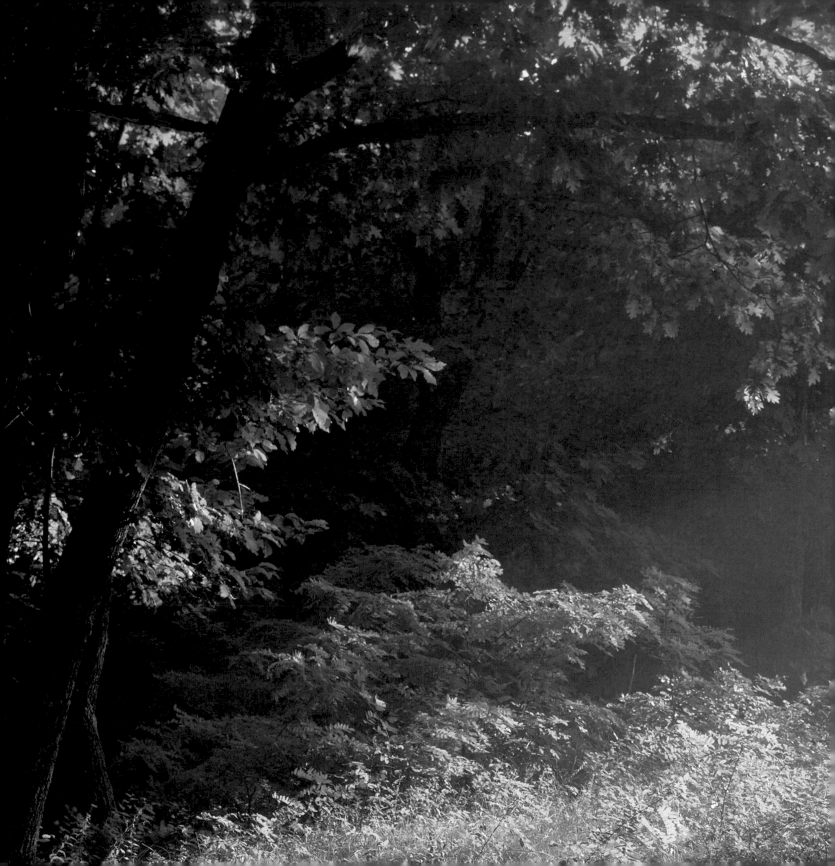

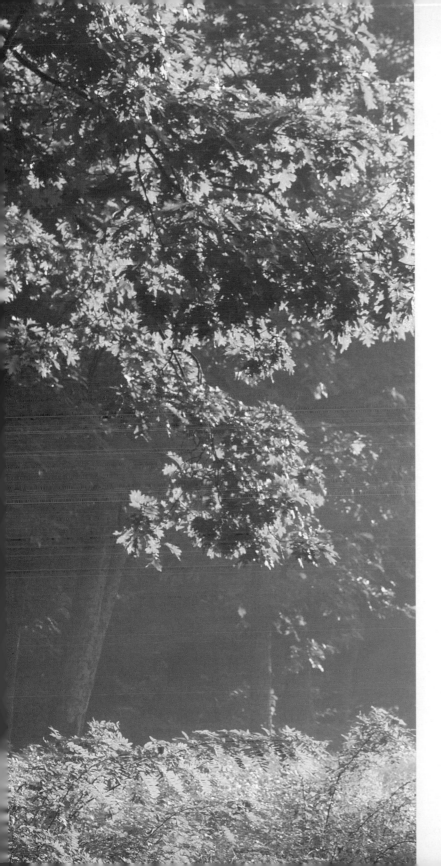

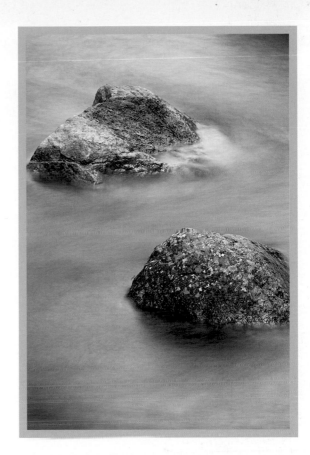

Left: Sunlight streams through a forest wilderness

Above: Reflections in Whiteoak Run

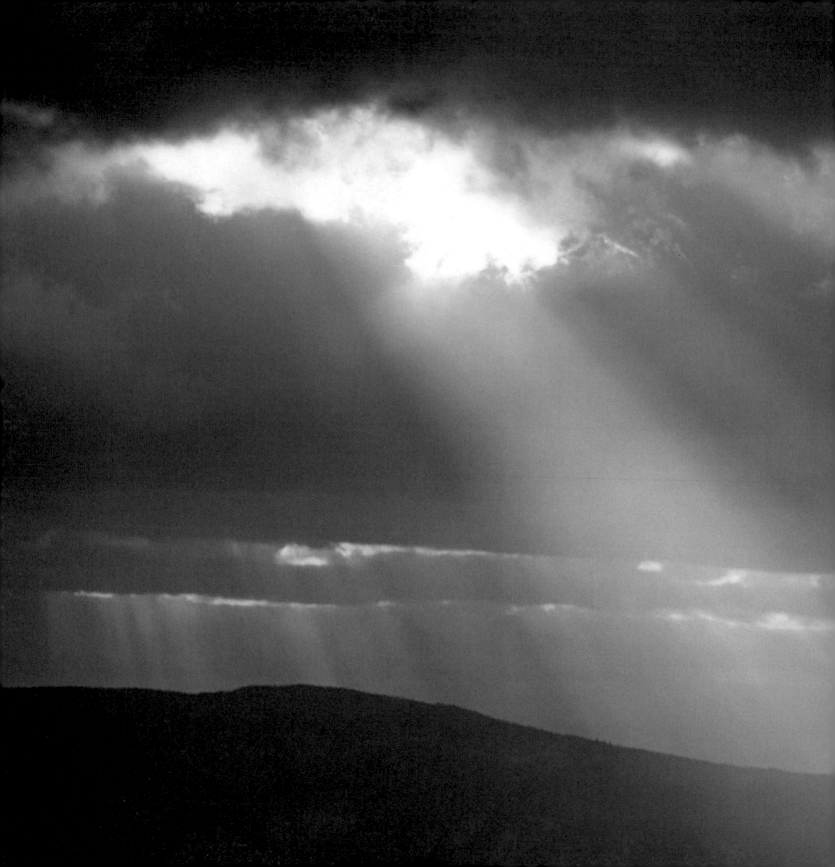

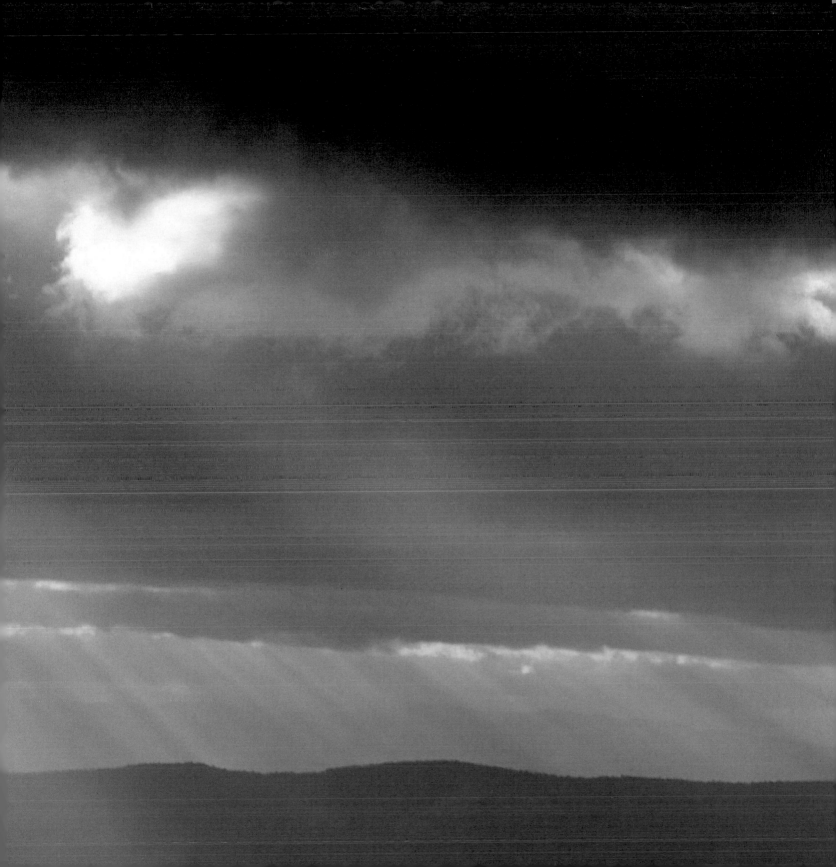

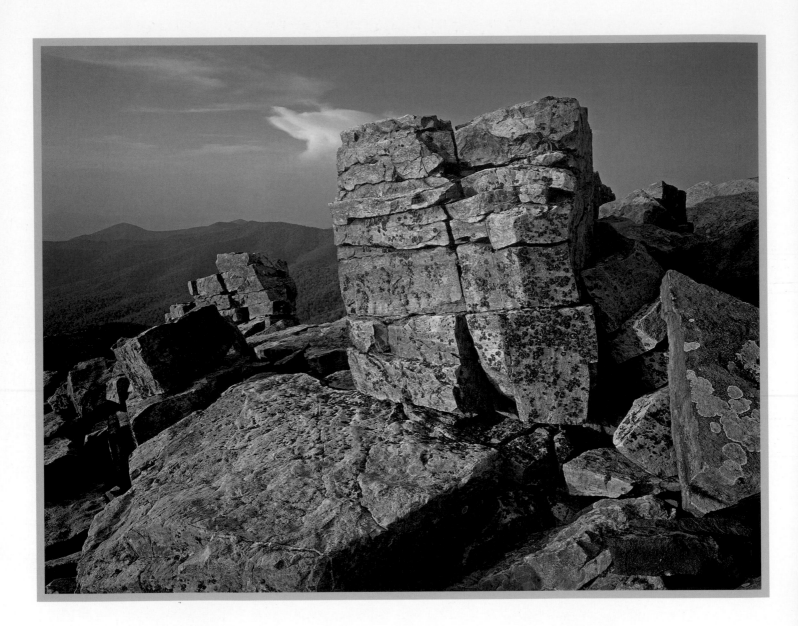

Previous page: Crepuscular rays

Above: The eroded cliffs of Blackrock Mountain

Right: Riprap below Stony Man Mountain

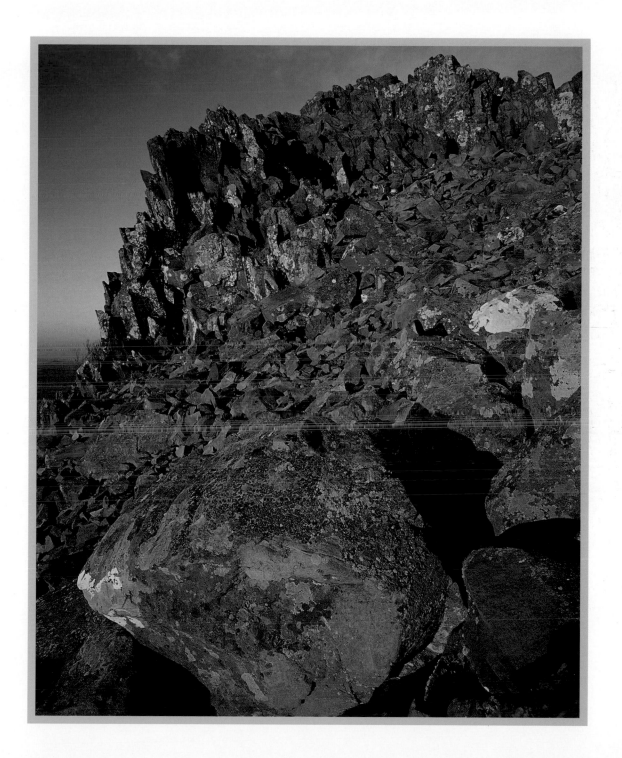

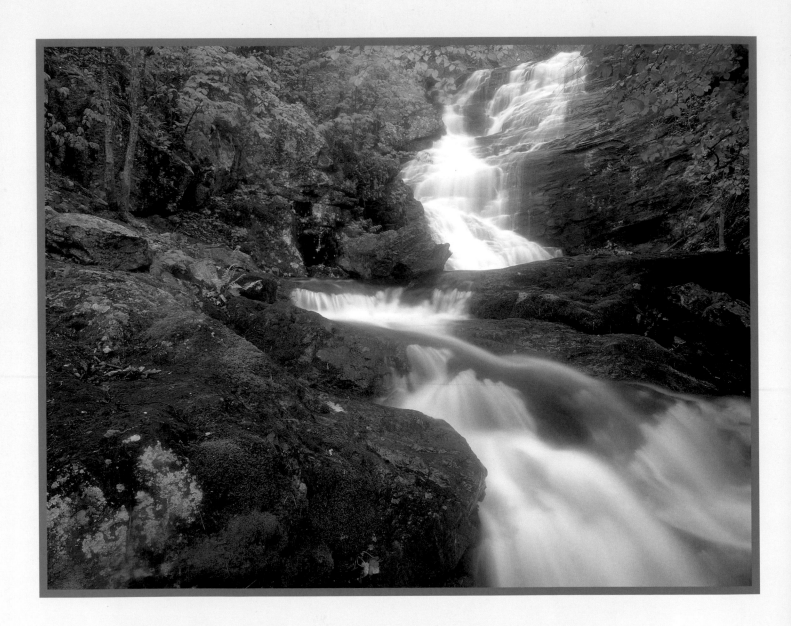

Above: Spring run-off courses down Overall Run

Right: Lower Doyles Falls framed by summer trees

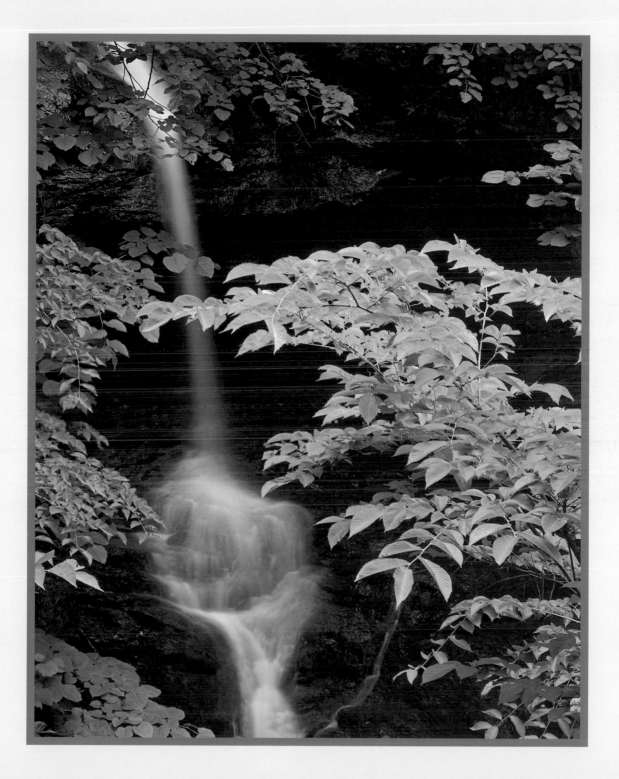

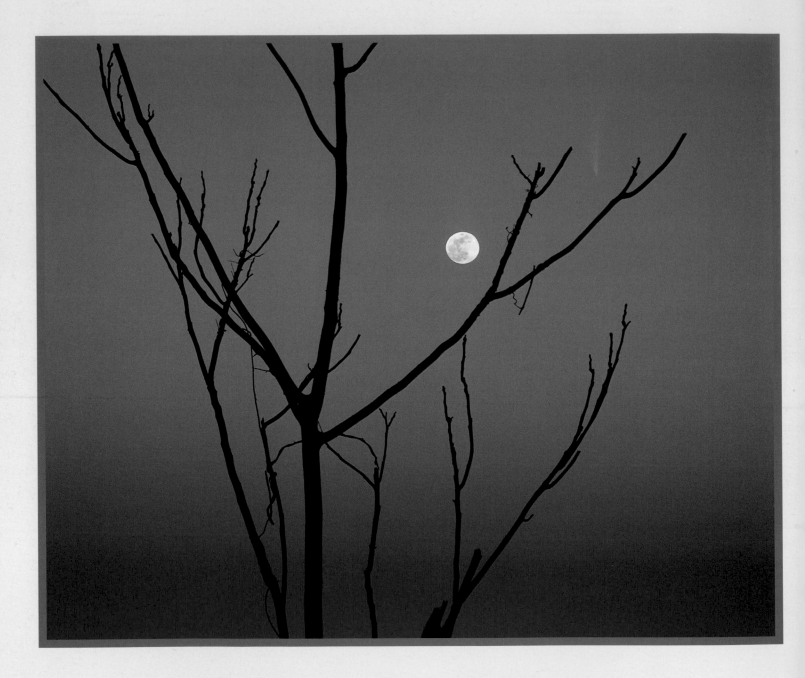

Above: A full moon rises above earthshadow and dusk's glow

Right: An autumn leaf floats above bubbles trapped in ice

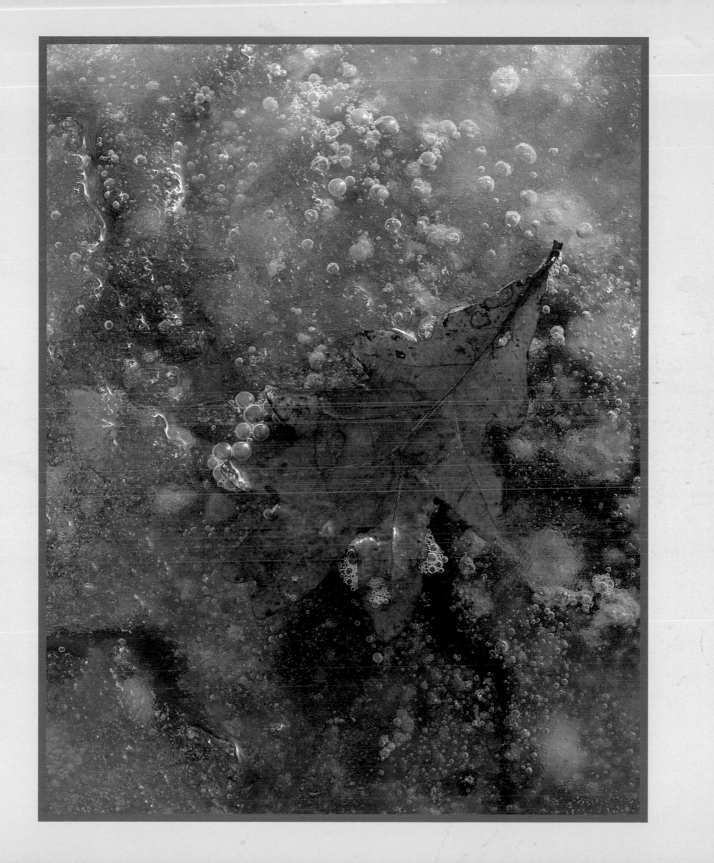

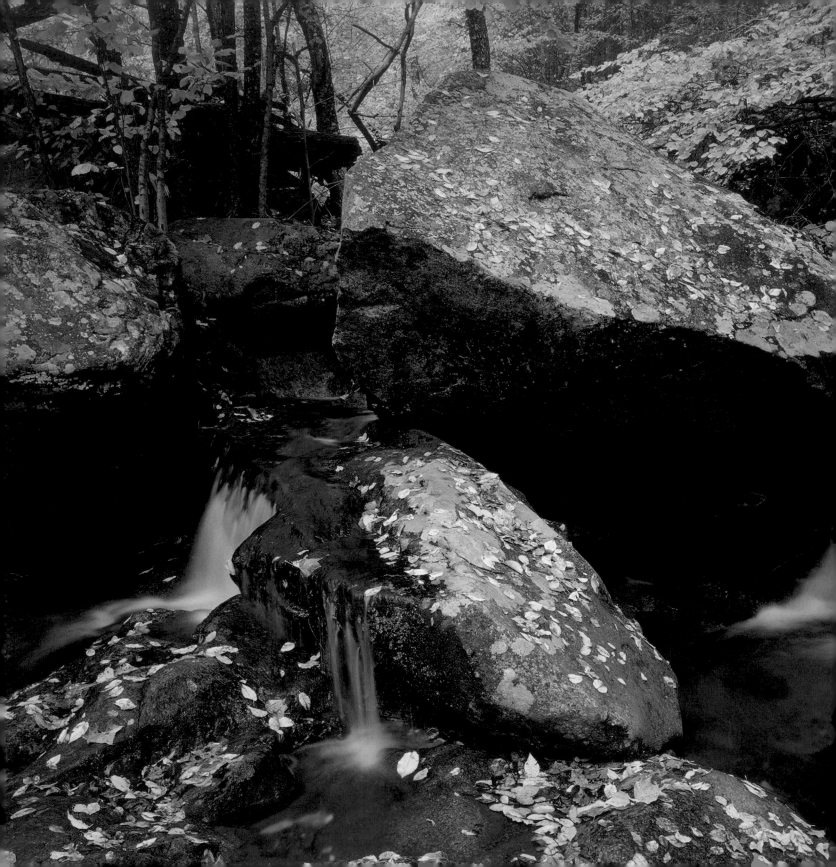

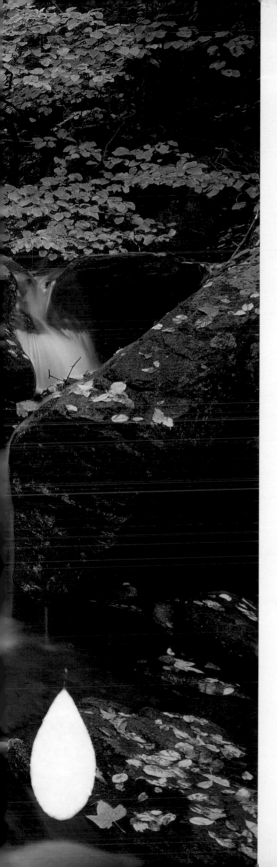

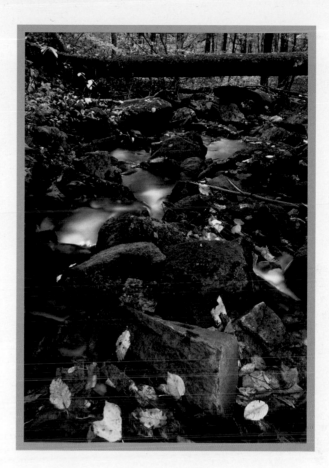

Left: Autumn view of Whiteoak Run

Above: Buck Hollow Run

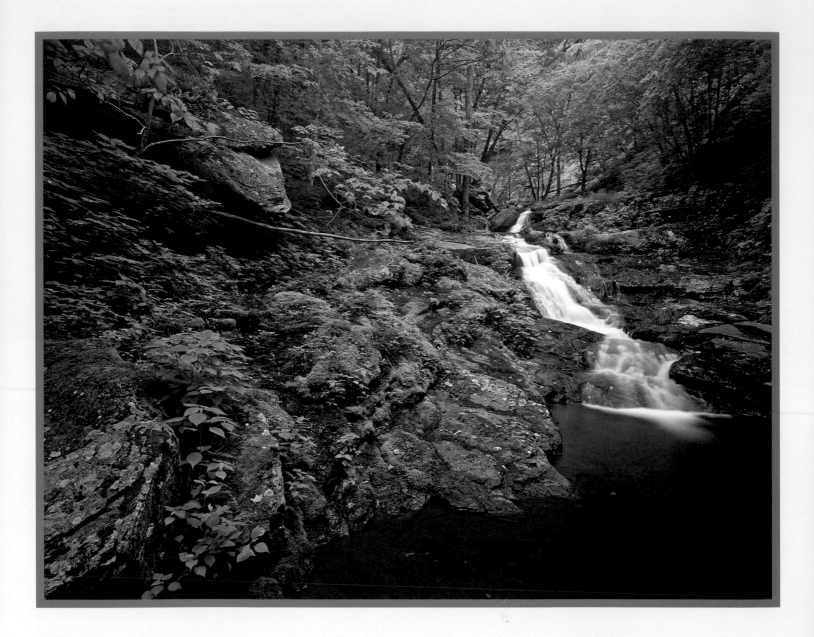

Above: Jones Run

Right: Lewis Spring Falls

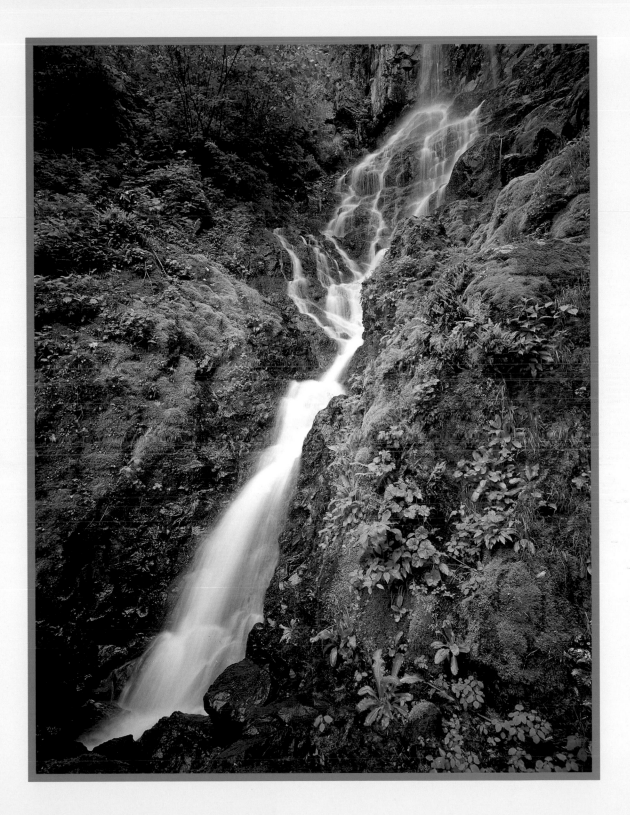

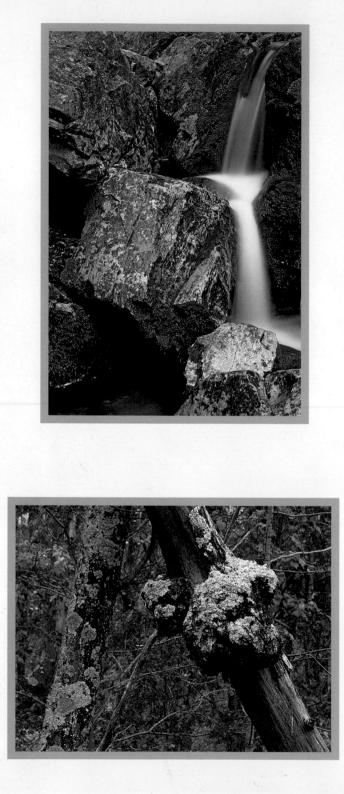

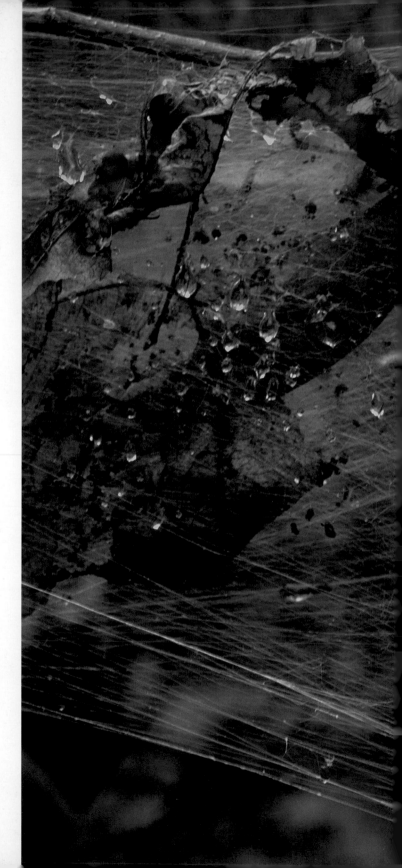

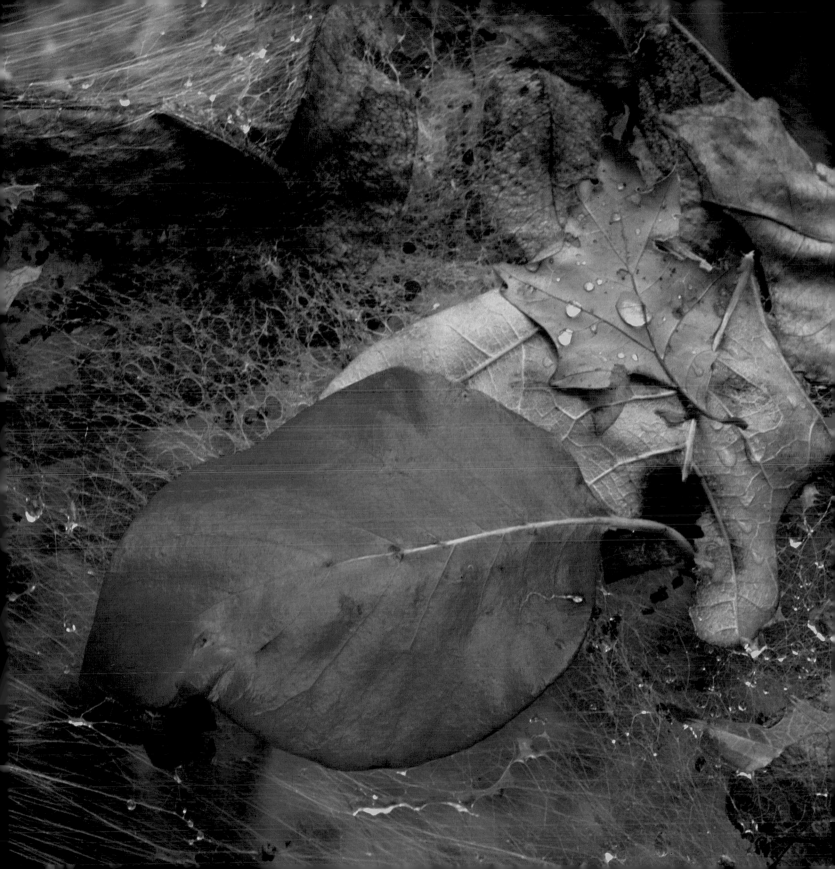

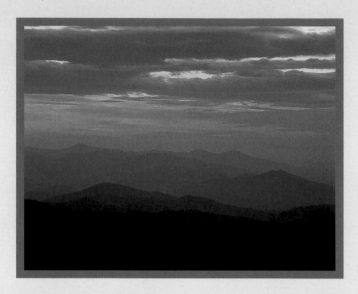

Previous page (upper left): Riprap Run Falls

Previous page (bottom left): Unusual growth on autumn trees

Previous page (right): An autumn leaf trapped in a spider's web

Above: Twilight view

Right: Fog fills the valleys below Thorofare Mountain Overlook

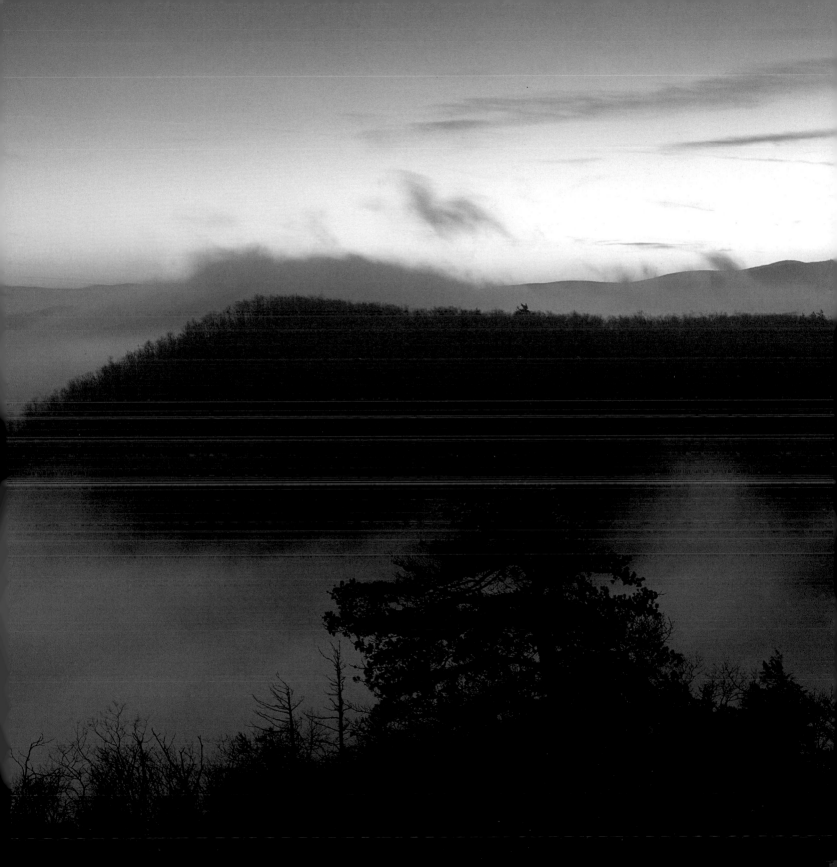

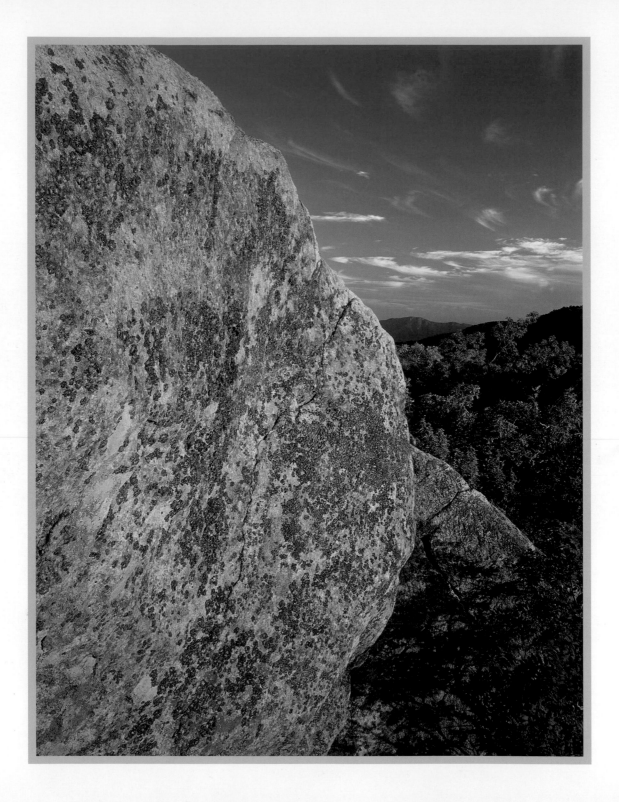

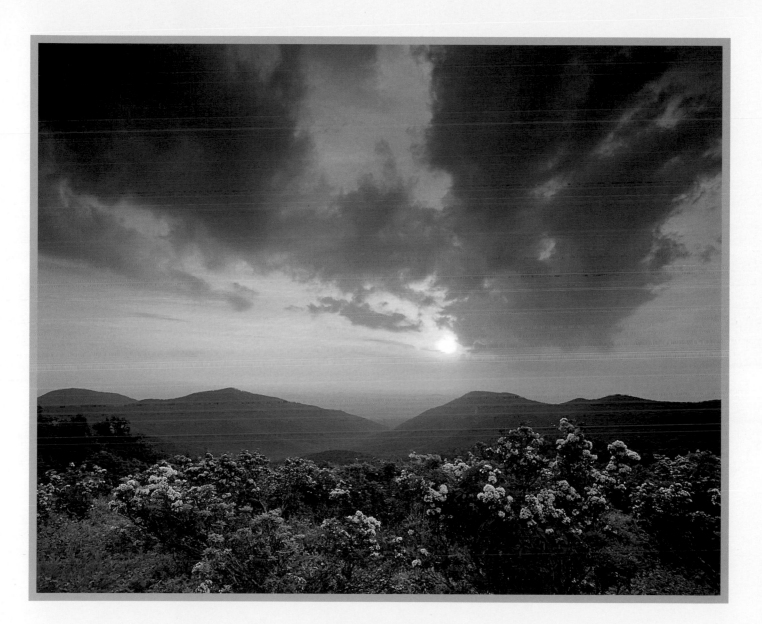

Left: Mary's Rock at sunset

Above: Mountain laurel blooms at Brown's Gap

Next page: Star trails over Old Rag Mountain

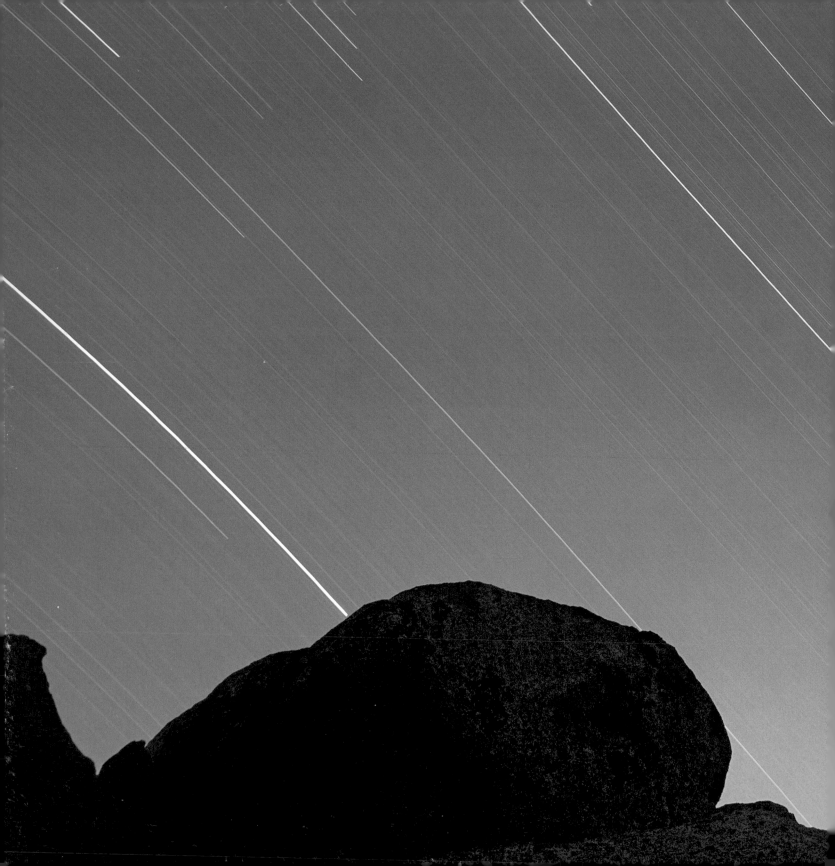

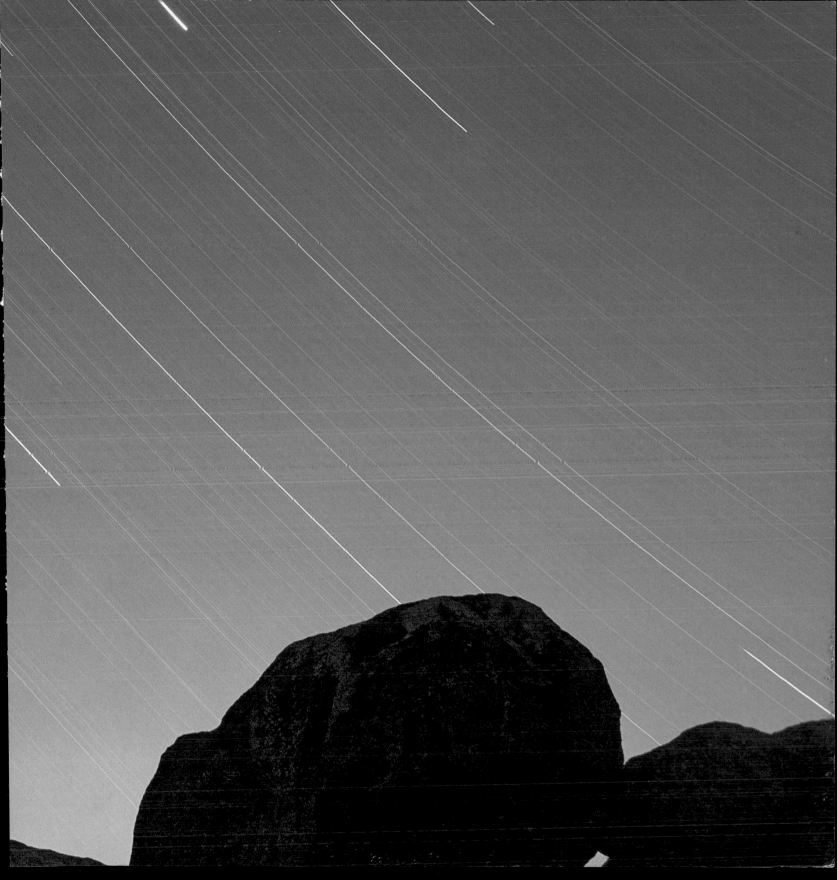

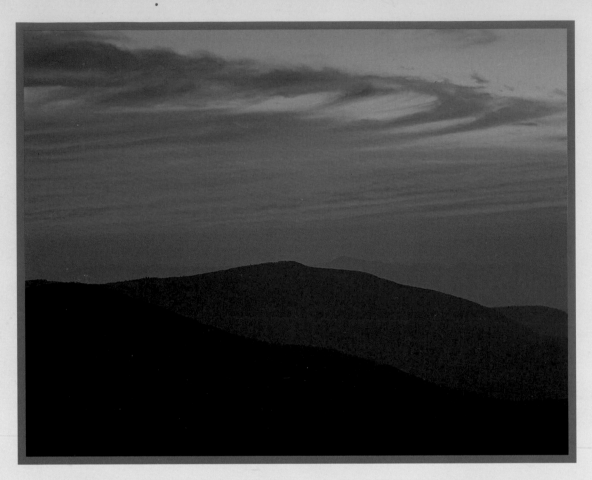

Above: The vibrant red tones of sunset descend over the Blue Ridge Mountains, from Stony Man Mountain

Back cover: Alpenglow reflects in a rainwater pool atop Little Stony Man Cliffs

About the Photographer: Ian J. Plant has been photographing the Blue Ridge Mountains for the past eight years. His work has appeared in a number of publications, including *Blue Ridge Country* and *Adirondack Life* magazines. Ian lives in Lorton, Virginia with his wife Kristin and their cat Kali.

Shenandoah Wonder and Light is Ian's first exclusive book. Ian's work also appears in *Virginia Wonder and Light*, a collaboration between Ian and Jerry D. Greer. Two more books by Ian and Jerry, *West Virginia Wonder and Light* and *Blue Ridge Parkway Wonder and Light*, will be available summer 2005.

www.ipphotography.com

You can see more of Ian's work on his website, www.ipphotography.com. There you can make on-line purchases of fine art prints of many of the images featured in this book, as well as other images from around the country.